PLACES AS ART

by Mike Lipske

NA
9052
.L56
1985

Commissioned by
Design Arts Program
National Endowment for the Arts

Published by
Publishing Center
for Cultural Resources
New York
1985

This book was commissioned
by the Design Arts Program of
the National Endowment for
the Arts.

Frank S. M. Hodsoll, Chairman
National Endowment for the Arts

Adele Chatfield-Taylor, Director
Design Arts Program

Charles Zucker, Deputy Director
Design Arts Program

Project Director/Editor: Marcia Sartwell

Designer: Miho
Photo Editor: Eileen Levitan

Library of Congress
Cataloging-in-Publication Data
Lipske, Mike.
Places as art.
"Commissioned by Design Arts Program National
Endowment for the Arts."
Bibliography: p.92
1. Urban beautification—United States.
2. Architecture—Environmental aspects—United States.
3. Architecture—United States—Psychological aspects.
I. National Endowment for the Arts. Design Arts
Program. II. Title.
NA9052.L56 1985 711′.4 85-19147
ISBN 0-89062-210-8
ISBN 0-89062-211-6 (pbk.)

Distributed by:
Publishing Center for Cultural Resources
625 Broadway
New York, N.Y. 10012

●

Author's Acknowledgements

Many persons shared time and knowledge without which this book could not have been written. Special thanks go to Charles Zucker, deputy director of the Design Arts Program, National Endowment for the Arts, who provided the idea and the plan for *Places as Art*. I also thank Marcia Sartwell, publications director, Design Arts Program, for steady editorial guidance; Thomas Walton, associate professor in the Department of Architecture, Catholic University of America, for assisting with research; and Cecilia I. Parker, for knowing the pitfalls peculiar to book-making and for suggesting ways around them.

—ML

FOREWORD

Foreword

The term "places as art" challenges us to look at our environment—and at art—in a new way. Usually we think of art as an object—something that hangs in a gallery—or as an event that takes place on a stage. Yet places can be works of art, too. They can satisfy our desire for beauty, stir our deepest feelings, link us to our history.

The concept of Places as Art gives us, in a sense, a new art form. It is made up in part of other art forms—sculpture, gardens, open space, buildings old and new, the decorative arts; it depends for its validity on the perception that the aesthetic whole is greater than the sum of its parts and that the beauty of the unity is the essence of its interest and importance.

The idea, of course, is not really new; history abounds in examples. To take just two: The Piazza Campidoglio in Rome was designed by Michelangelo to incorporate existing buildings, the great statue of Marcus Aurelius, churches, steps, footpaths, and so on. One could not categorize the activity that created the piazza as architecture, urban design, historic preservation, city planning, or set design, because it is all those things.

Yet it is more than the sum of all those things. Disparate elements have been drawn into a harmonious whole and lifted to a new level of beauty and meaning.

The Lawn at the University of Virginia is another example, this one closer to home, and, to a greater extent, conceived at one time. Jefferson's plan has as its centerpiece a rotunda, which is flanked by colonnades and by pavilions, five on each side. Behind the pavilions are living quarters, gardens, and serpentine walls. Here is a combination of architecture, urban design, and landscaping. Its place as one of the world's great conceptions derives not from any one aspect or building but from the order and purpose that underlie the whole.

Sometimes, of course, places acquire aesthetic significance that has more to do with the passage of time than with design per se. Over the years they take on new meaning as landmarks, or as vessels that hold our memories. The changes that accrue over the centuries can create, quite by accident, an interrelationship of buildings and landscape that is precisely right—a place that is art. Such a place, for example, is the Tiber Island in Rome, a conglomeration of significant

and insignificant buildings that over time has become an irreducible aesthetic entity. For the most part, though, building Places as Art requires conscious purpose, vision, and the means to realize that vision.

In past civilizations, the rich and powerful could create great places more or less by decree; consider, for example, how Florence's Piazza della Signoria was shaped by the purpose and vision of the Medici.

But in out time, and in our democracy, if we are to have more places that are works of art, we must have an informed and interested citizenry that understands the value of art as well as the processes that encourage its creation.

Great art—whether a painting or a plaza—cannot be forced, but it can be fostered. In twentieth-century America, Places as Art are most likely to come into being when a community believes, first of all, that aesthetic values are worth pursuing; and, second, that it is through art that a community best expresses its ideals and aspirations. When such a community articulates the vision it has of itself, when it has clear intentions and an understanding of good design, then wonderful things may happen.

The idea of Places as Art has nothing to do with a particular style. It has, on the other hand, a great deal to do with "process"—with the way different communities manage to make design excellence as issue whenever they build new places or save old ones.

There is no single process for creating Places as Art. That is why this book identifies several paths—ways that individuals, associations, institutions, and governments have gone about getting the subject of urban aesthetics before the community.

Not every one of those attempts to create Places as Art will strike every citizen or student of design as suitable or satisfactory. Perceptions and resources differ. Yet, it seems to me, any good-faith attempt to make a place beautiful and whole is a step in the right direction.

During much of the twentieth century, we have seen the fragmenting of the arts—the break-up of art forms into smaller pieces, each aimed at addressing the special needs of smaller audiences. But in the last twenty years, there have been aesthetic movements that call for the eye and the mind to integrate the whole. Places as Art is one of these movements, calling for a new awareness of coherence and unity in the arts, especially the arts that make up our environment.

It is our hope that this book will spur that movement forward, stimulating the creation and celebration of new Places as Art and the burnishing and expansion of existing ones—activities that will greatly enhance the American landscape and engage the American spirit.

Adele Chatfield-Taylor
August 1985

LET THERE BE ART

When Lord Brabazon asked members of the House of Lords to censure London construction work in 1962 — expressing his dismay over "the recent erection of buildings of a skyscraper type in the Metropolis from the aesthetic and aeronautical point of view" — his complaint was an early trickle in what has become a river of criticism.

Not everyone condemns skyscrapers, of course. But there is abundant evidence, in newspaper and magazine articles, in books, in symposiums and panel discussions, in conversations half-heard above the din of construction downtown, that more and more people are unhappy with the form and feel of their cities.

The dissatisfaction with urban design and architecture goes beyond the usual complaints about speculative over-construction of office space, about projects that come in over budget and late, or about the sort of logical lapse that results in a commuter town's newest office tower being built without a parking lot. Our displeasure centers on something less palpable — the lack of Brabazon's "aesthetic . . . point of view." Call it the acute shortage of built beauty.

"If we don't demand good architecture, we don't deserve it, and we won't get it," growled Robert Campbell, architecture critic for the Boston *Globe*, when he recently inaugurated annual awards for "the most awful buildings" in Boston. Testing the curative power of shame (not just for architects, but also for clients, government officials, and citizens who foster or accept bad design), Campbell proposed prizes for a "forbidding gray fortress" masquerading as a shopping/hotel complex, for "an upended radiator" of a high-rise that "offers not the least hint that its purposes include human habitation," and for five more of Boston's "ugliest and most life-degrading buildings of the year."

Campbell's stab at negative reinforcement is only one example of recent criticism of the designed environment. Ronald Lee Fleming and Renata von Tscharner, of the Townscape Institute in Cambridge, Massachu-

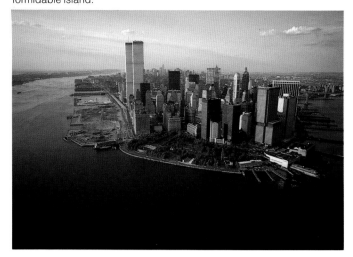

Tall towers crowd Manhattan's shore. "It is as beautiful a land as one can hope to tread upon," said Henry Hudson. A trading post from the start, New Amsterdam gave way to the agglomeration of cement, steel, and glass that makes for our most architecturally formidable island.

The city is a fact in nature, like a cave, a run of mackerel or an ant-heap. But it is also a conscious work of art...The dome and the spire, the open avenue and the closed court, tell the story, not merely of different physical accommodations, but of essentially different conceptions of man's destiny...With language itself [the city] remains man's greatest work of art.

Lewis Mumford, *The Culture of Cities*

setts, write of the "banal sameness" that "haunts the old commercial strip on the road to the airport as well as the sparkling new development downtown." Another observer speaks of "windswept . . . American plazas" as "our cities' equivalent to the strip mine, desperately in need of reclamation." Another decries the rise of "marketecture" — office towers designed solely for commercial appeal, in the manner of candy bars and new cars.

"There is almost no one who is not bewildered by the events of the last two decades in architecture," wrote Paul Goldberger, of the New York *Times*, in a 1981 review of what he called "the hottest topic in Manhattan's architectural salons," Tom Wolfe's *From Bauhaus To Our House*. Readers of Wolfe's attack on minimalist excess, in the form of International Style architecture, could be found well beyond Manhattan's salons. Fourteen weeks on the *Times* best-seller list and a Book of the Month Club selection, *Bauhaus* — with 130,000 copies sold in hardcover — may still stand as the ultimate evidence of public dismay over contemporary architecture. Probably not every reader yearned for buildings that, as Wolfe wrote, "catered to the Hog-stomping Baroque exuberance of American civilization." But one may assume many felt short-changed, even betrayed, by the places they saw as they traveled about their town or city. One did not have to be a British Lord to sense that buildings had become less breath-taking, that from the square top of the newest high-rise to the barren slab at its base something critical was lacking, that the city center seemed as formula-built as the temples of fast food on the interstate, that the mall at the north end of town replicated the one at the south. One did not have to be a Brabazon to know that places can be art.

We are accustomed to thinking of art as an object that hangs in a gallery or sits in a plaza. We also think of art as an event — a concert or opera or play. But places can be works of art. An Italian piazza or a New England village green each has the capacity to quicken our senses, stir our emotions, and convey aesthetic integrity. Each

links us to the people who created it. Each holds our history.

Buildings — the best of them — are more than shelter. An old structure, whether courthouse or counting-house, becomes a stone vessel of civic culture. A new building, born of a high-stakes design competition and still as crisp as the architect's drawings, can fire imaginations and focus a young city's vision of its place in events to come.

"The urban landscape, among its many roles, is also something to be seen, to be remembered, and to delight in," planner and educator Kevin Lynch wrote in *The Image of the City*. "As an artificial world, the city should be so in the best sense: made by art, shaped for human purposes."

Shaped with grace and well-crafted, the city is stage and backdrop for our daily urban drama. Yet too often we sense that the set is ill-proportioned, the lighting unfocused, the play poorly written. We might leave — mayor or man on the street — if we did not suspect we were members of the cast and not just the audience. We know the shopping mall is not a village green, that the library plaza with its concrete benches is no Piazza San Marco, that Brutalist buildings are too aptly named. We know we can churn out office towers almost as effortlessly as we can fried-chicken stands, but must they look so . . . churned out?

Why is it that, as the *Globe's* Robert Campbell says, "The places we value and love so much . . . have almost never been created in our own time"? The answer, he suggests, has little to do with nostalgia. "It has to do with the things that make a city, any city in any period, livable for human beings. It has to do, above all, with creating a humane public realm . . . We can often make good buildings today, but seldom good public realms. When we think of great cities we think first of their great public streets But where in our time have we created a single great street?"

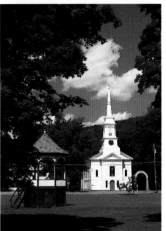

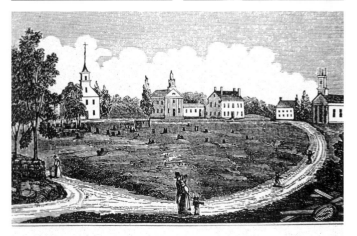

New Canaan

What is the city but the people?

William Shakespeare, *Coriolanus*

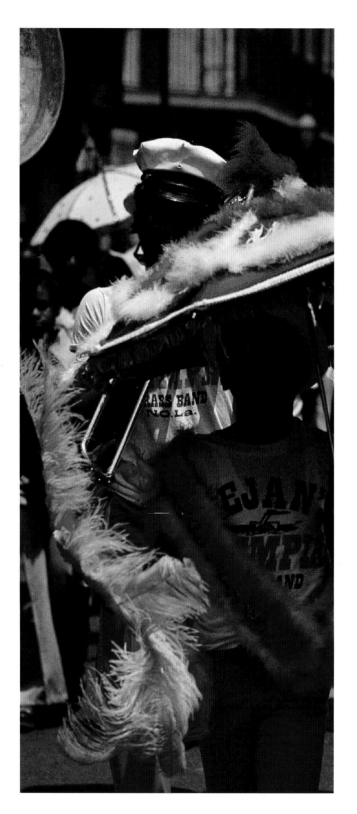

Ours is a quantifying age. The concept of places as art is, on the other hand, not something that can be measured off in square feet or calculated as a percentage of the municipal budget. As real as the Statue of Liberty, the "art" in "place" remains as intangible as your memory of Manhattan at a precise moment after dusk.

Art — a welded-steel abstraction — may not render a plaza a "place as art." However, function — a Seattle manhole cover embellished with an artist's design of a whale — may make of a streetcorner a "place."

In a recent catalog of books on planning, there were advertisements for reports and texts on the use of microcomputers, on sign control, on economic development, on zoning, on how to be an expert witness. There were, and are, no manuals on creating places as art. Yet the idea is old, as old as hills with classical temples on their summits.

Genius loci — spirit of place — is the ancient concept that most closely suggests the meaning of, and means of creating, places as art. In Bellows Falls, Vermont, a row of nineteenth-century storefronts — with facades restored and signs improved by young businessmen — could draw warm applause from the deities that the Romans said were guardians of every special place. In Miami, with its breezier gods, spirit of place might be better expressed by a condominium with a large hole in its middle, as well as by the palm tree and whirlpool bath nestled within the twelfth-floor skycourt. ("Beach Blanket Bauhaus," is how Patricia Leigh Brown, in *Esquire*, described the work of Arquitectonica, the Florida firm that designed the condominium and other new buildings that "fit the city snugly, like some wayward architectural bikini.") In Santa Fe, New Mexico, an "adobe" house — with stucco and paint over cinderblock walls — constitutes an acceptable offering to art, tradition, and the forms of Pueblo Spanish Revival Style. In Escondido, California, a growing community in search of its public image, plans for a new civic/cultural center, developed through a recent architectural design competition, represent now-and-future *genius loci*, for "places as art" can say not only what we are but what we hope to become.

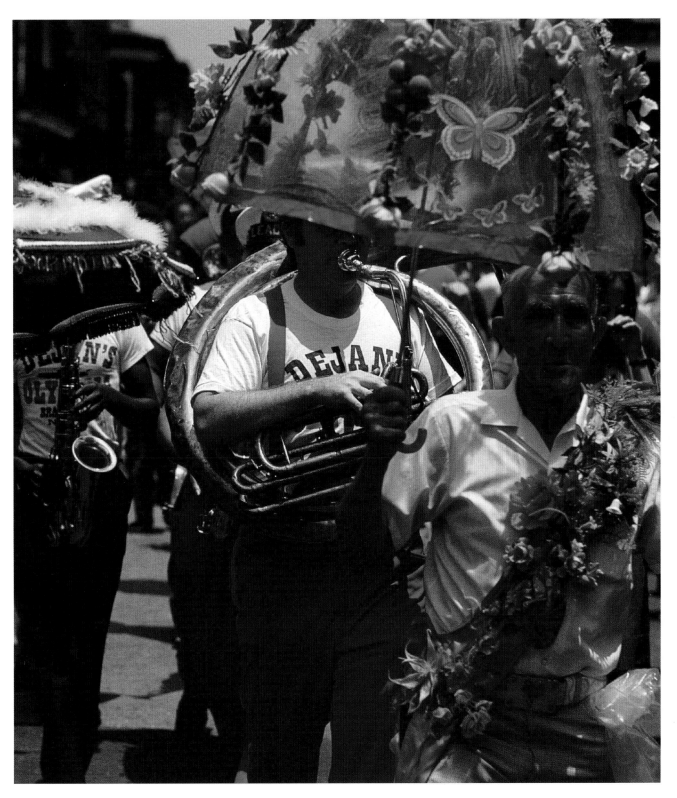

A brass band marches down
Bourbon Street, giving voice to the
spirit of New Orleans.

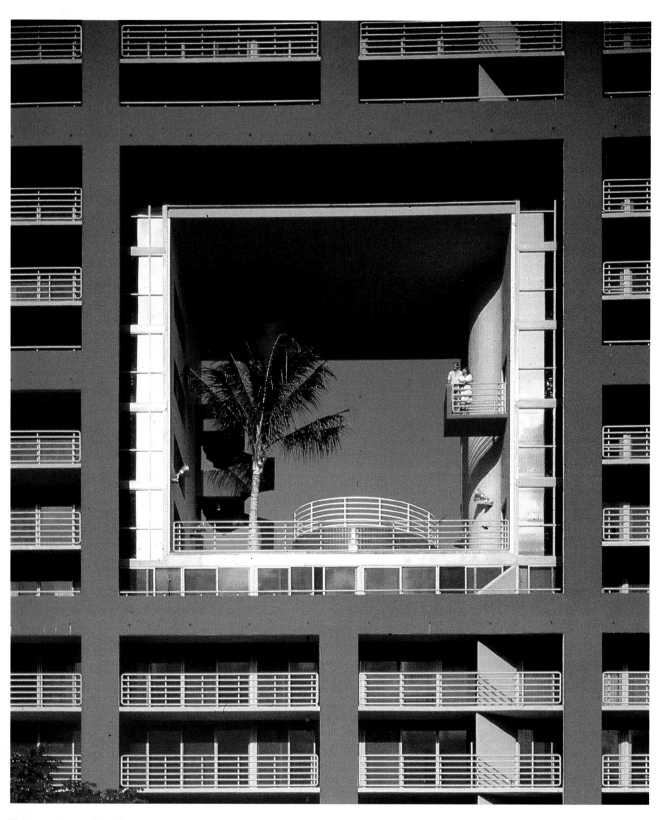

Eight apartments share the
skycourt at the Atlantis, a 20-story
condominium at the edge of
Biscayne Bay in Miami.

The concept of places as art is an acknowledgement that color, form, texture, balance, and composition merit equal consideration with the economic and social demands that guide planning and development. New places as art are created, and old ones saved, when leaders recognize and articulate the vision of self shared by a community, and when they foster cooperation among the hundreds of place-markers that transform the city daily. Thus the concept travels with questions: How does one give voice and, ultimately, substance to the intangible? How does one popularize the notion that the form of the urban environment is, among other things, an artistic issue?

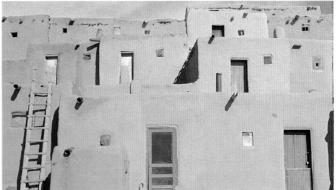

One can try summoning expert testimony. "Architecture," said the English critic John Ruskin, "is the art which so disposes and adorns the edifices raised by man, that the sight of them may contribute to his mental health, power, and pleasure." What Kevin Lynch called "a distinctive and legible environment" may be a balm for urban anxiety and, at the same time, "heightens the potential depth and intensity of human experience."

However, if an expert student of the city such as Lynch knew that vivid urban settings were more than luxury, he also knew how difficult it can be to chart a course toward improvement. No single artist creates a place as art, for the city, wrote Lynch, "is the product of many builders who are constantly modifying the structure for reasons of their own," and "only partial control can be exercised over its growth and form."

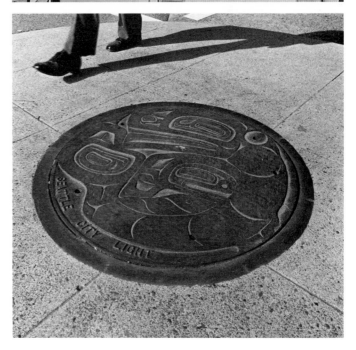

In the crash and din of urban development, arguments for beautiful buildings that rise from harmonious settings may go barely heard. Mistaking price for value, people may say that truly great design is simply too expensive. Yet the scale of the budget and the scope of return on investment must be measured against potential long-term gains.

No matter how monumental the initial cost of a new building, or of any development project, that sum may represent less than half of eventual costs. Be it a highrise, a shopping center, or a downtown park, the completed project must be operated and maintained, and such costs are influenced by the quality of design. The

Now suited to Steinways, Bulfinch
Square was restored by Graham
Gund Associates. The complex
bears the name of the Boston-born
architect of Faneuil Hall and the
Massachusetts State House.

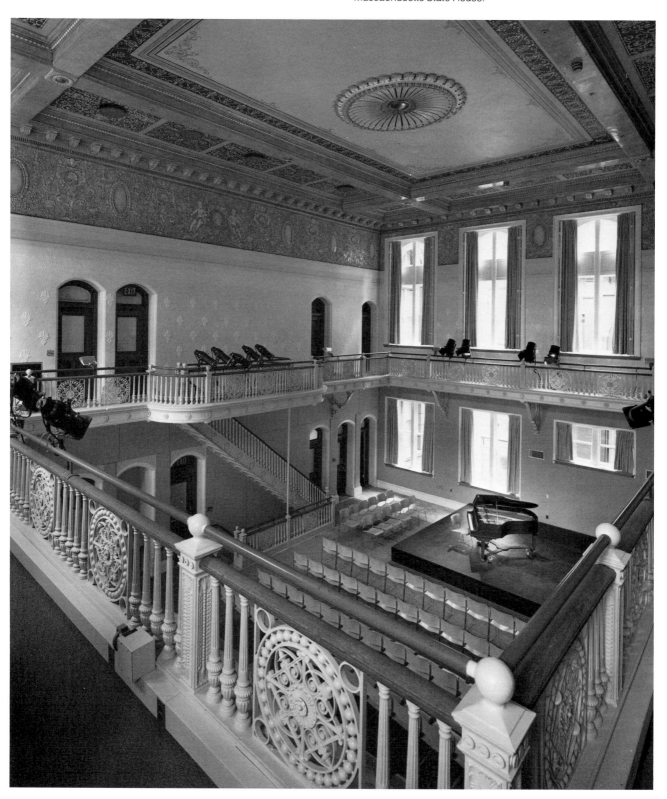

useful life of a building, its attractiveness in the local or national marketplace, its responsiveness to present and future management plans, its ability to foster employee productivity — each needs to be considered along with today's design and construction expenses.

Beautiful places attract tourists and, of course, tourist dollars. However, the well-conceived city may also draw new business in the form of corporations seeking a rewarding environment for workers. The city government that fosters great public architecture also sets the tone for better private architecture. (Call it inspired leadership or peer pressure, the effect is the same: quality begets quality.) And, while good design is not the cure for every urban ill, the city that is legible as opposed to chaotic, that rewards the senses rather than insults them, also heightens community pride and spirit. In New York, our capital of graffiti, consider the eight-foot, fiberglass pear that hangs at street level outside a Grand Union supermarket on East 86th Street. Designed by Milton Glaser, the pear "is voluptuous, sensual; the color a soothing pale green," reports *Smithsonian* magazine. Furthermore, "the neighborhood has paid it the ultimate compliment: in more than two years [Glaser's] pear has never known the touch of a felt-tipped pen."

Educating the eye, places as art spawn an aesthetically sensitized public, and all that that may bode for better design and development in years to come. Such places constitute the ultimate act of civility toward citizens grown cynical about the ruling deities, be they public or private. And such places are being created in American cities. Officials and developers, architects and artists are finding the means to breathe substance into an aesthetic concept. They are saying places as art matter, and are laying their convictions on foundations of cement.

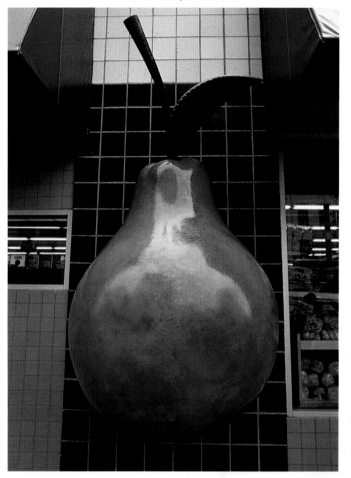

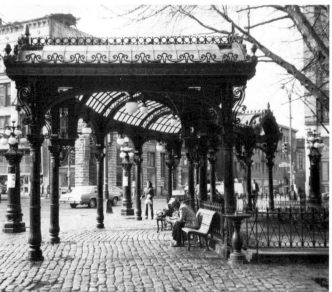

I found Rome a city of bricks and left it a city of marble.

Augustus Caesar

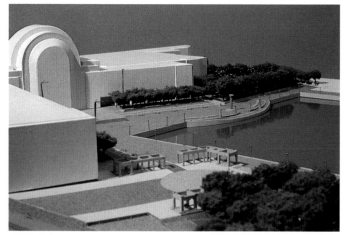

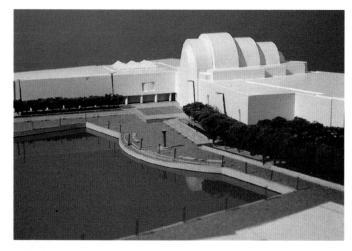

"San Marco on the Hudson," the plaza at the World Financial Center, in New York's Battery Park City development, will be the first major public square on the river. The three-and-a-half-acre space, with view of the Statue of Liberty, was designed by artists, an architect, and a landscape architect.

"It's going to be a fabulous, wonderful place," says Victor Ganz. "It could be an American, latter-day San Marco." Ganz, an art collector and retired businessman who is chairman of the fine arts committee for New York's Battery Park City development, is talking about a San Marco on the Hudson River, a three-and-a-half-acre public plaza, across from the Statue of Liberty, that has been jointly designed by an architect, artists, and a landscape architect.

Scheduled for completion in 1988, the waterfront plaza is being called a keystone to Battery Park City, the massive residential and commercial community being built on 92 acres of landfill at the tip of lower Manhattan. (When Battery Park City is fully developed, it is estimated that its working population will be 31,000 people, its residential population about 30,000.) The plaza will serve as a link between the Hudson and the World Financial Center, the complex of office towers and glass-covered "wintergarden" that has been designed by architect Cesar Pelli. Surrounding a cove on the river and incorporating a section of Battery Park City's 1.2-mile waterfront esplanade, the plaza — with its eight unified-but-distinct spaces — will accommodate individuals, small groups, and large gatherings. Intended as a major public amenity for all New Yorkers, the space was designed by Pelli, artists Siah Armajani and Scott Burton, and landscape architect M. Paul Friedberg.

Reaction to the plaza design, at least in the pages of the New York *Times*, has gone beyond favorable. "There are fountains, steps, a walking path along the Hudson River, a lawn for playing frisbee. There seems a place for every conceivable public desire, from meditating at the river to nailing down a business deal at lunch."

"The plaza will function as both stage and auditorium," goes another account, "and when we walk across it we shall feel twice ourselves."

"I didn't want us looking at so-called 'plunk art,'" says Victor Ganz. He credits the excellence of Battery Park's fine arts committee (members include art historians, an

architect, a curator from the Whitney Museum, and other arts professionals), and the fact that the committee was granted "a hell of a lot of autonomy" by the Battery Park City administration, with enabling the group to plot a redefinition of the roles of architect and artist in the design of public places. Of the plaza design, Ganz says, "I believe it represents the first example of an intensely close and frank collaboration among architect, artists, and landscape architect in the *total* development of a major urban space from its very beginning." Rather than embellish a plaza with art objects, Battery Park's developers, urged on by Ganz's committee, are creating a place as art, as well as a working addition to New York's public realm.

Not every city will stage developments the size of Battery Park. But metropolitan weight is not a requirement in the planning and creation of places as art. In Seattle, a city with a population around one-fourteenth that of New York's, local artists have worked, along with architects and engineers, on design teams for a number of public projects. The city's Viewland - Hoffman electrical substation, with an abstract mural along the back wall and a whirligig compound that displays work by two Washington folk artists, was Seattle's first such project. Completed several years ago, Viewland - Hoffman has won awards for its design. Artists have gone on to collaborate with architects on other Seattle City Light substations.

Not surprisingly, however, there were initial reservations about the role of artists in designing public works. "City Light said, 'What are you people doing? What a strange idea. Is it appropriate to put artists to work on a substation?' " recalls Richard Andrews, then administrator of the Seattle Arts Commission's Art in Public Places Program.

Paid from city percent-for-art funds, Seattle artists have helped design police stations, parks, bridges, and sidewalks. Artist Jack Mackie, member of a design team developing a new look for a stretch of Seattle's Broadway Avenue, created *Dancer's Series: Steps,* bronze dance instructions inlaid in the pavement at

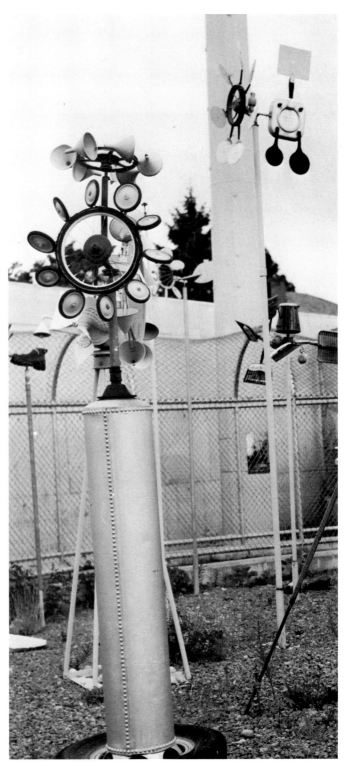

Whirligigs made by folk artists Emil and Veva Gehrke were incorporated into the design of Viewland-Hoffman electrical substation in north Seattle.

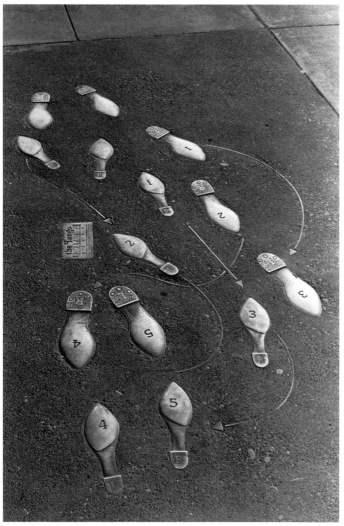

Bronze dance steps, by artist Jack Mackie, teach the tango and enliven a Seattle sidewalk.

eight locations on Capitol Hill. Embellishing city sidewalks with diagrams for foxtrots and rumbas is one way of enlivening what Andrews has called "the generally anonymous vacuum of American streetscapes."

"The complete lack of surprise in American streetscapes is an awful failure," says Andrews, now director of the Visual Arts Program at the National Endowment for the Arts. "In many European cities, you walk around and are never sure what's going to be around the next corner. In American urban design, you always know what's around the corner."

Creating an element of urban surprise takes a bit of planning. Not long ago, the Seattle Arts Commission hired an artist and a designer to prepare a study of existing and future possibilities for incorporating art into the city's downtown core. "In commissioning this study," Andrews wrote in the introduction to *Artwork Network*, "we make the assumption that artists have a fundamental place in city planning. As the downtown changes and as an increasing number of buildings are constructed in a style concerned more with filling zoning envelopes than with creating a cohesive urban landscape, the role of art in the city takes on increased importance."

Seattle's *Artwork Network* study recommends sites for art, and for projects involving artists in design, throughout the city's "network of primary public places." Traffic islands, parks, alleys, proposed monorail stations, sidewalks scheduled for repair, even an unused drive-up book return at the Seattle Public Library are identified in the study as places to put art and places to become art.

"There are no real guidelines for any of this yet — we're just making up procedures as we go along," Richard Andrews, in an interview in *The New Yorker* magazine, said of Seattle's efforts to inject artists into urban design. "A lot of city-owned space is in streets and sidewalks, you know, and triangles between streets — leftover spaces of all kinds. . . . We want to give artists an opportunity to shake up everybody's thinking, including their own."

At a Minneapolis music shop customers know where to park.

AN ART OF CITY
DESIGN WILL WAIT
UPON AN INFORMED
AND CRITICAL
AUDIENCE.
Kevin Lynch, *The Image of the City*

The authors of Seattle's *Artwork Network* study observe "that the places which come to identify a city are often those preserved or developed by government. . . . Although some of the finest urban spaces in Seattle . . . have been privately developed, private interests tend to develop uses downtown that are too specialized to capture any sense of the community's character."

In the Boston *Globe*, critic Robert Campbell writes, "It's crazy to expect a variety of developers and architects, each independently pursuing separate goals, to produce building that will magically aggregate into good streets and urban spaces They have to be given rules that will insure that each new building will do its part in creating the public realm."

Builder and rulemaker, local government sets the tone for city form. In creating the public realm — whether a new city hall or a new sidewalk — government defines our expectations of urban design. Through its actions as well as its declarations, it can make informed design clients of citizens, creating a climate where the aesthetic point of view in architecture and development is not merely appreciated, but anticipated.

Other institutions in the community can also raise the issue of quality. The case studies in the next chapter provide examples of ways in which academia, the press, industry, professional societies, individuals, and government have created, critiqued, or simply cheered along potential places as art. A sampling of other means for improving urban design follows:

◆ The Washington Monument and St. Louis' Gateway Arch, Boston's City Hall and the U.S. Capitol, the Eiffel Tower and the Sydney Opera House have one thing in common. Each is a product of design competitions, an old and reliable method of fostering architectural excellence. Design competitions can help

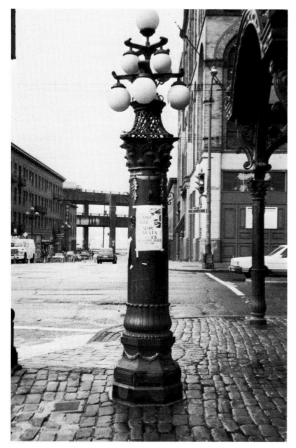

Ornate street lamp and cobblestone pavement keep contemporary Seattle in touch with the past.

Where the soaring starts: At the
Gateway Arch in St. Louis, two
young visitors inspect the
foundation of our tallest monument.

**A great city is that which has the greatest men
and women.**

Walt Whitman, *Song of the Broad-Axe*

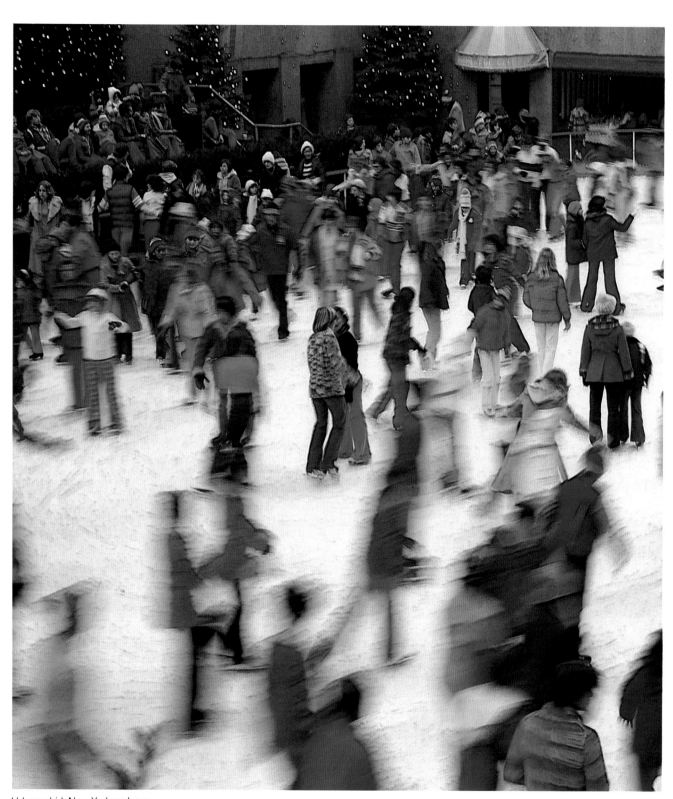

Urban whirl: New Yorkers have
skated in Rockefeller Center's
sunken plaza, off Fifth Avenue,
since Christmas Day in 1936.

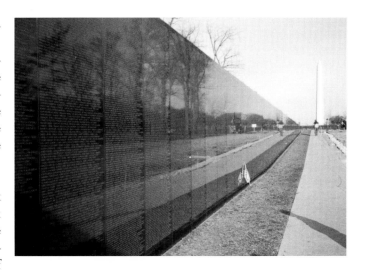

crystallize a community's vision of itself, let lesser-known talent compete with established professionals, even boost a capital fund-raising drive. Types of competitions range from "open," to "invited," to "on-site charettes." Advice on choosing the best style of competition and on how to manage one successfully can be obtained from local and state design societies, state arts councils, and the National Endowment for the Arts.

● Some county and state governments have found it helpful to publish design manuals or policies that set standards for public architecture. A Kansas state design manual, for example, defines architectural aesthetics as "the interplay of planes; the proportions of height, width, and length; the combination of contrast and continuity; and the use of materials . . . [to] create beauty and enhance the purpose and presence of a structure." Final design of state projects, declares the manual, "should be exemplary to others in the [architectural] profession and be worthy of representation of the state of Kansas."

▲ City review boards and arts commissions can function as design watchdogs, with local architects and other appointed citizens studying development proposals and, when necessary, seeking modifications in design. In Baltimore, the city's design advisory panel, composed of architects, landscape architects, and architectural historians, meets regularly to review publicly funded projects. The Seattle Arts Commission, whose membership includes artists, engineers, architects, and urban planners, performs a similar role, advising city government on the design of capital improvement projects. In Kansas City, Missouri, the municipal arts commission has been called that city's "aesthetic conscience." Its members review and approve plans for public projects, and examine elements of private development (from lighting to landscaping) that impinge on the public realm.

■ Cities without a review board can address the subject of urban design in other ways. In early 1984, Phoenix Mayor Terry Goddard established an ad hoc advisory committee on the arts to help "change the face

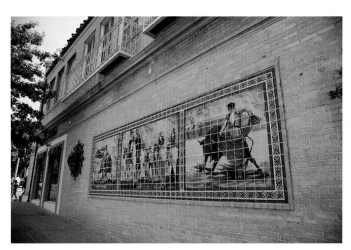

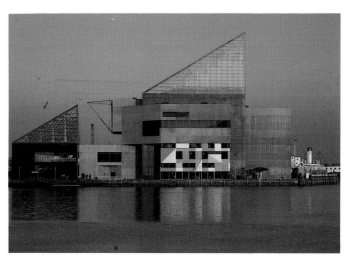

Man fights bull in a tile mural at the Plaza shopping center, in Kansas City, Missouri. Below, new National Aquarium hoists sail in Baltimore's Inner Harbor.

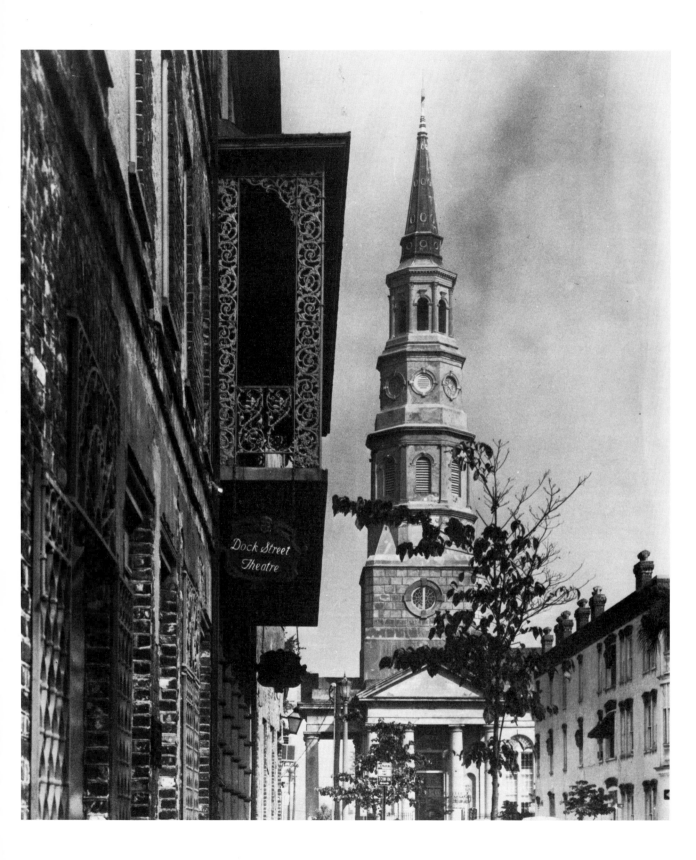

of Phoenix in the next five years by substantially improving the 'look' of the City and the cultural quality of life in the City." The 26-member committee was expected to investigate the desirability of a city arts commission and of adopting legislation to set aside a percentage of municipal construction funds for the "artistic enrichment of the City." The committee was also asked to study "various possibilities of City beautification," including "such things as securing professional painting and landscaping advice for blocks or neighborhoods which desire to 'spruce up,' the installation of decorative street lamps, benches, flowerbeds, and other facets of 'streetscapes' for both downtown Phoenix and outlying areas."

▼ Art institutions can encourage a fresh look at their hometown. In May 1983, the Walker Art Center, in Minneapolis, sponsored a three-day public symposium that focused on four central city projects in the planning or construction stage. A bus tour to each site was followed by presentations from project architects and planners. Invited "respondents" — six nationally recognized experts in architecture, preservation, and development — then discussed the projects in terms of their relation to the city as a whole, the range of urban amenities they might provide to a broad cross-section of the community, and their outstanding characteristics as architecture and urban "place." Results of the symposium, which was called *Minneapolis Profile 1983*, were published as a special issue of the Walker Art Center's *Design Quarterly*. "Our feeling is, the more informed the public is, the better chance we have for better architecture," Mildred Friedman, the center's design curator, says of thinking behind the symposium. "We're not trying to make architecture critics out of the public. What we're asking is, 'What is the impact of this development?' What we're trying to create here is an aware audience, so that when something is proposed here, they have some awareness of what the impact of big structures, and small structures, will be on the city."

❑ In many cities, attempts to enhance the urban image go astray by relying on imported models for development. The desire for improvement is sincere, but the result is architectural sameness. Where possi-

Preservation comes naturally in Charleston, South Carolina (above and at left). A Society for the Preservation of Old Dwellings was established in 1920. The city's first historic-district ordinance was passed 11 years later. The Dock Street Theatre, just down from St. Philip's Church, was restored during the 1930s, with Works Progress Administration help.

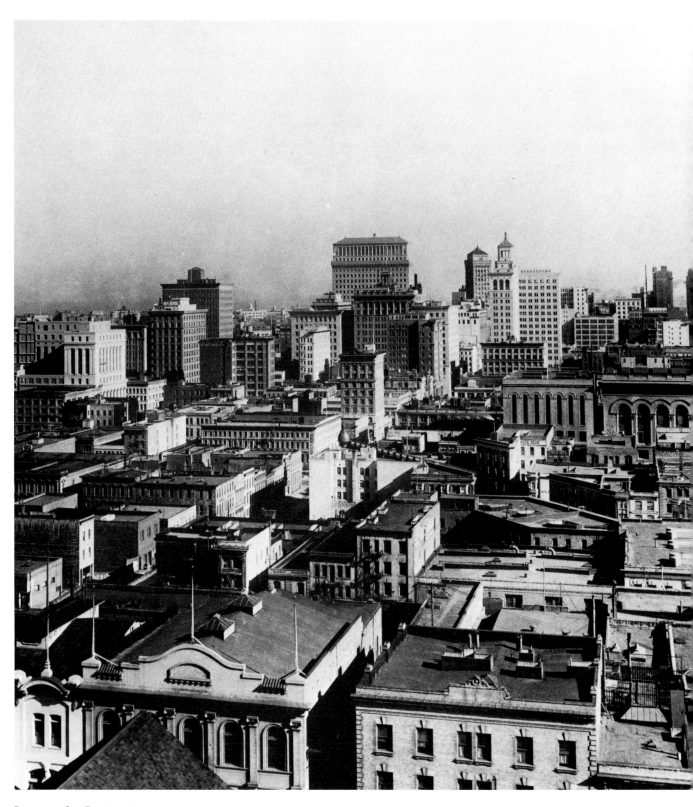

Downtown San Francisco's
sculptured skyline during the
1920 s.

ble, it may make more sense to encourage those building types and architectural styles that constitute a signature for local taste. In San Francisco, for example, a proposed downtown plan criticizes the "bulkiness and repetitive boxiness of many recent structures [that] have obscured the fine-scale sculptured skyline of pre-World War II San Francisco." The plan recommends buildings with "generally thinner and more complex shapes" as well as "more expressive, sculptured building tops." According to Jonathan Malone, a member of the city planning department, the document "doesn't say every building has to look like the Chrysler Building or the Empire State Building." It does, however, express as desirable "the evolution of a San Francisco imagery that departs from the austere, flat top box — a facade cut off in space." Other cities take sterner steps to hold the line against foreign styles. In Santa Fe, New Mexico, one of the country's oldest historic-district ordinances (written in 1957, revised during 1982-83) calls for design review, usually by a board whose members are appointed by the mayor, of remodeling, additions, new construction, and demolition in five city historic districts. In Santa Fe's core historic district, all remodeling and new construction must adhere to what are known as the Pueblo Spanish Revival or Territorial Styles of architecture.

Santa Fe's consciousness of urban design tradition predates its ordinance. A 1912 map of the city, showing public improvements proposed by the planning board of that time, bears the legend "Ancient Streets To Be Left Undisturbed." According to *Design & Preservation in Santa Fe*, a 1977 study prepared by the city-planning department, the historic-district ordinance represents more than legislation for the protection of adobe. The study notes that the ordinance "put much of the city's cultural aesthetic development into the hands of Santa Fe residents rather than those of the developer. . . . what came out of the ordinance is the view of the people of Santa Fe. . . . it is an expression of the population regarding the perceived character of the community."

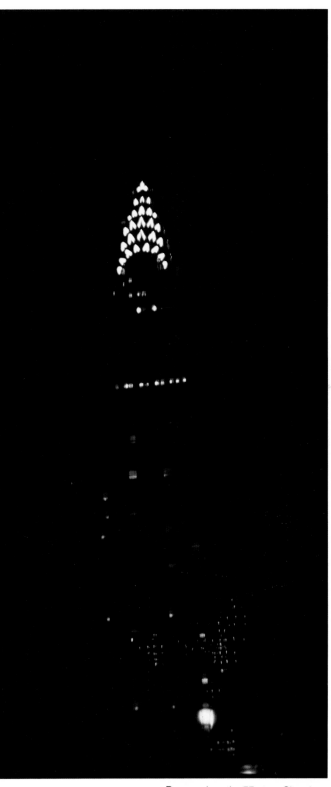

Dome aglow, the 77-story Chrysler Building, in New York City, was a summit of Art-Deco flair when it was completed in 1930.

Prescriptive ordinances, advisory boards, design competitions — all can preserve or create places as art. But cities and towns are complicated environments, with more on the agenda than architecture. In America, not every city has a sufficiency of pre-World War II skyline to suggest an alternative to architectural standardization. Not every town has the consciousness of architectural heritage or, for that matter, the heritage itself that a Santa Fe does. Even in cities with a past, change roars in with a force that seems to preclude planning for art. "Proposals for blockbuster new buildings [in Boston] surface so often they dull the imagination. . . . such growth is the architectural equivalent of the Big Bang," writes the *Globe's* Robert Campbell.

In any large urban project, city officials and developers conduct negotiations that establish a building's use, the materials it will be made of, the location of its entrances, the amenities it will offer. Calls for an aesthetic intent in development may be resented, and resisted, as a troublesome addition to an already complicated, highly political process. Yet processes change. There are new things under the sun — Battery Park City and its arts committee with "a hell of a lot of autonomy" being one massive example.

For better or worse, we build as we believe. A cathedral or a curbstone may each signify what we aspired to in our finer moments, or only that we worked with one eye on the budget and the other on the clock.

"Architecture presents man, literature tells you about him, painting will picture him to you," believed Frank Lloyd Wright. "You can listen and hear him, but if you want to realize him and experience him go into his buildings, and that's where you'll find him as he is. He can't hide there from you and he can't hide from himself."

Frank Lloyd Wright and his 1910
Robie House, in Chicago.

Place-Makers at Work

"Few Americans think that city-making is a fine art," wrote city planner and author Kevin Lynch. "We may at times enjoy a city, but only as a fact of nature—just there, like a mountain or the sea. But, of course, we are mistaken; cities are created objects, and at times in history they were managed and experienced as if they were works of art. However misshapen, a city is an *intended* landscape."

Many Americans may still take for granted the cities they inhabit. But more and more of us—from architects to state governors—are demonstrating our appreciation of the intentions behind place-making, and of the benefits of thoughtful, intentional design.

Each of the following case studies details an attempt to come to terms with the issue of quality in place-making. One, a privately managed awards program, simply drew attention to well designed, but for the most part overlooked, buildings. Another tells of an effort to focus public attention on the nature of city-making, an effort made in the belief that a better informed citizenry is our best guarantee of better civic space. Still others were attempts to encourage excellence in public architecture, or to cure social ills through careful redesign and through the commissioning of public art.

Although most city-making is the work of government, perhaps the important lesson in these examples is that individuals and non-government institutions can take the lead in advocating design excellence and artistic merit in development of public facilities. A professional society, a school of art, a newspaper, a corporate patron—each can advance the cause of places as art.

Philadelphia: Private Awards to Inform Designers and Their Public

"Select, though not elite," is how the Philadelphia *Inquirer*, in the mid-1970s, described winners of that city's privately administered building-of-the-month

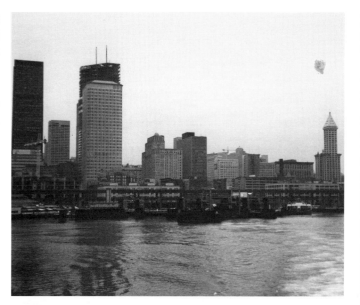

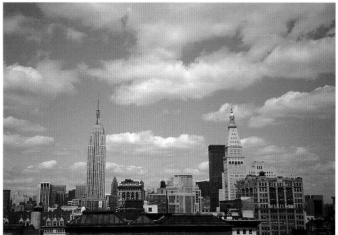

Similar cityscapes: From top, Seattle, New York, and Chicago.

"All those things—signage, decoration—that architects are so reluctant to use are part of what makes up a city. It was a way of telling architects to look at the vernacular."

awards. Understandable, given that honored buildings included a Passyunk Avenue pizzeria, an Atlantic City fudge shop, and a shocking-pink brick rowhouse on North Lawrence Street. If art was here, one sometimes had to squint to see it.

But for David Slovic, the Philadelphia architect who conceived of the awards, and who today acknowledges "the funkiness of the concept," the monthly prizes were also a serious matter. For one thing, says Slovic, the awards were intended "to get people in the city looking at the environment more, to become more aware that the city has a lot of riches. I thought of them as a teaching tool. I was propagandizing for architecture."

At the same time they instructed the lay public, buildings-of-the-month were meant to serve as continuing education for the city's architects. "The choices . . . did raise specific issues about architecture, design, and urban living," Slovic wrote in the spring 1984 issue of the journal *Places*. "For architects, who have the tendency to identify as architecture only what is built by the educated hand and eye of other architects, the Building-of-the-Month Award was a public celebration, a lesson in public aesthetics."

During 1976 and 1977, Slovic and his partners at Friday Architects/Planners handed out twenty building-of-the-month awards. Certificates—each embossed with a gold seal that bore, in Latin, the motto, "Everyone is to be trusted in his own special art"—went to a diner, a medical center, two Dodge dealerships, a municipal Christmas-light arrangement, and other winners. "We tried to keep them fairly topical," says Slovic, who now has his own architecture and urban-design firm in Philadelphia. "In September, we did a school. In August, we'd do something at the shore."

Neighborhood newspapers published press releases and photographs that accompanied each month's award, according "instant landmark" status to local winners, says Slovic. "The buildings selected were not always great buildings," he says. "But they always had one great feature. Therefore in articles about monthly

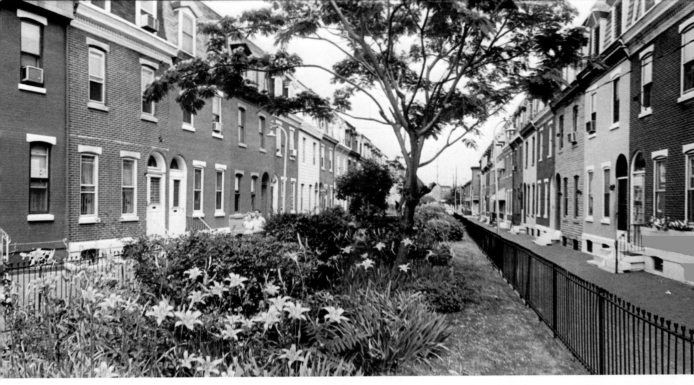

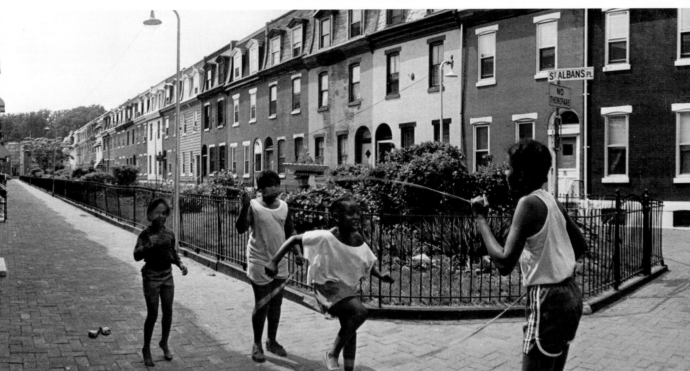

At St. Albans Place, Philadelphia, townhouses that date from the 1870s enclose a garden-street that has no automobile traffic.

winners you'd learn about design through that one feature."

One award winner, an Italian restaurant, was honored by Friday Architects for its 1939 exterior, with "an easy-to-read neon sign complete with chef" and "an outstanding black-and-white tile design that charmingly integrates signs and decoration, giving the entire street frontage a cheerful and inviting look."

A small church was singled out for its "effective use of architectural symbolism to enhance a building's function," namely the "permastone facade . . . in the shape of a peaked roof typical of one-story churches" that had been applied to the front of the two-story stucco building.

By pointing out the symbolic facade on the church or the sign on the pizza parlor, says Slovic, building-of-the-month awards also told "architects, who at that time were debating whether these things were good for their buildings, 'Look around you.' All those things — signage, decoration — that architects are so hesitant to use are part of what makes up a city. It was a way of telling architects, the trained people, to look at the vernacular." Recognize the "tenacious optimism" expressed by a shocking-pink rowhouse, as Slovic wrote in *Places*, and the perceptive designer may grasp "the means for making authentic places emanate from the patterns of life at hand."

Slovic says Friday Architects abandoned private award-making because it became too time-consuming. But he still believes cities can benefit from similar programs that honor architectural diamonds in the rough and rhinestone rowhouses.

"Each community should be encouraged to do something like that," he says. "I meant to encourage people to use their own judgement. That then becomes a part of public discussion. Then people really look around and say, 'What's good that *we* have?'"

As for members of his own profession, he says, "We, as architects, enliven people's experiences. I felt, as far as

Tough tree: Fan-shaped ginkgo leaves fall on North American sidewalks every autumn. Grown in temple gardens in China and Japan since ancient times, ginkgoes fare better than most trees in polluted modern cities. Sole representative of a group of related plants that were abundant 165 million years ago, ginkgoes are living fossils, believed to no longer exist in the wild.

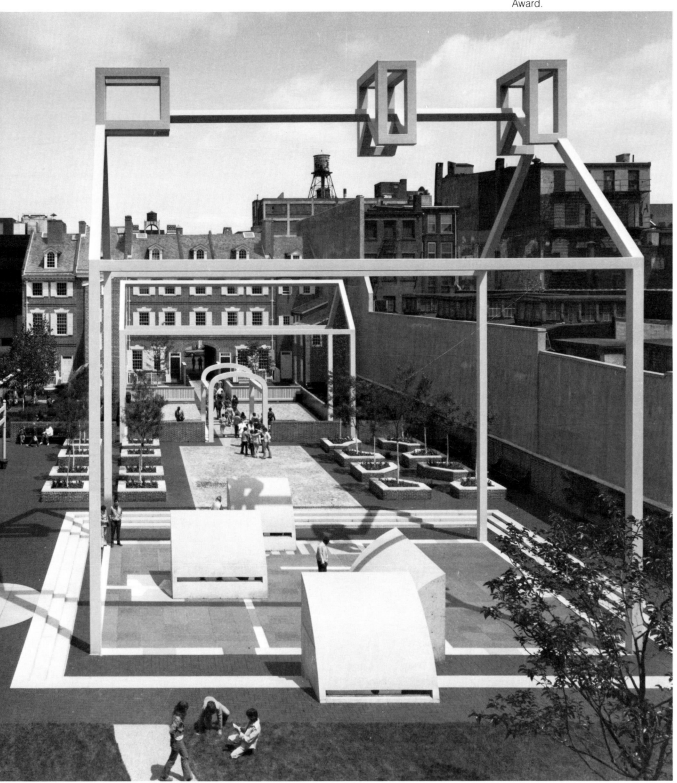

Steel framing evokes the Philadelphia house where Ben Franklin lived. The floor plan is detailed in white marble set in black slate. A museum sits below ground. Franklin Court, a Bicentennial project by the architectural firm of Venturi, Rauch and Scott Brown, won a 1984 Presidential Design Award.

the sensitivity behind these buildings, if architects could learn from that and look at that, then we could make better buildings. To look at how people live, and not at what other designers have already conceived of, I think that's really key."

Colorado and Florida: State Prizes for Places

Professional societies and state governments can do much to focus public attention on exemplary architecture. Awards programs in Colorado and Florida have each honored outstanding place-makers in order to encourage better design in private and public development projects.

"I would like to give everybody the inclination to ask themselves what they want in their particular community," says Denver architect Stuart Ohlson, founder of the award-making Colorado Design Alliance. "If we can't have selfish interests in the places we occupy, we're going to be subject to the conditions of development, rather than controlling them."

Colorado's "energy boom, which seemed to represent a growth in development and population," says Ohlson, was the impetus for forming the Colorado Design Alliance in 1982. (The alliance's membership is drawn from state chapters of the American Institute of Architects, American Society of Landscape Architects, and American Planning Association, and from the Consulting Engineers Council of Colorado.) With the state's population expected to soar and the number of buildings within its borders expected to double, alliance members felt Colorado citizens should be encouraged to help guide the design professionals who will shape the state's physical development.

"We weren't anti-growth," says Ohlson. "We wanted to encourage those who were in the design and develop-

Tourists crowd the restored Main Street of Breckenridge, Colorado, winner of a 1983 award from the state's private Design Alliance. Breckenridge was listed as a ghost town in some guidebooks as recently as the 1960s. The town's enactment of strict historic-district guidelines, in the 1970s, was complemented by private restoration work.

ment game to do the best possible work. One of our objectives was to provide a forum through which observations, attitudes, criticisms could be dealt with effectively. The Columbine Awards were an attempt to channel that."

For the alliance's 1983 Columbine Awards for Design Excellence, the professional organization divided Colorado into five geographic regions and, through newspaper balloting, asked citizens to vote for the best of the state's buildings, plazas, streets, and other designed projects. Nominations were solicited through newspaper articles about the awards; names and telephone numbers of local alliance members were published, and readers were asked to suggest favorite projects. Regional ballots were then published in newspapers, and readers voted for one of five projects in their area or wrote in their own candidate for a design award.

Throughout Colorado, more than 4,000 Columbine ballots were cast. The mixed-use development Writer Square (described in the Denver *Daily Journal* as "an architectural bridge between the historic low-rise buildings of adjacent Larimer Square and the modern high-rise buildings of the new downtown Denver") was the winner among Denver-region voters. Other Columbine winners included a resort development near Durango, Colorado, and the restored Main Street of the former mining town of Breckenridge. In a ceremony at the Denver Botanic Gardens in June 1983, Columbine Award plaques were presented to local officials, architects, engineers, and others responsible for each winning project.

In Florida, the Governor's Design Awards program, begun in 1980, also aims to focus public attention on good design, but with the goal of encouraging better use of taxpayer dollars.

Richard Chalmers, dean of the School of Architecture at Florida A & M University, says the awards program grew out of a conversation with Governor Bob Graham. "Our governor is very interested in building and architecture," says Chalmers. "Back five years ago, we were talking and we asked what incentive is there for agen-

Rewired, original lighting fixtures illuminate the house at the restored Saenger Theater, in Pensacola, winner of a 1984 Florida Governor's Design Award. Denver-area voters chose Writer Square (top) to receive a 1983 Columbine Award in Colorado.

cies of government to use the taxpayers' money in a way that results in better architecture." Chalmers says Gov. Graham suggested the annual awards program that would recognize outstanding public projects.

Nominations for the annual awards, invited in eight categories that range from educational facilities to restoration-and-recycling projects, can come from any agency of local or state government. "The user makes the nomination," says an official in the governor's office of planning and budgeting. "That's the ultimate test of a public building," he says, adding that each nominated building must also have been in continuous use for two or more years.

As in Colorado, recognition — in the form of a certificate — goes to every member of the development team, including the government official who oversaw completion of the winning project. A bronze plaque is mounted on the actual structure selected by the awards jury. Each year's jury is composed of members of Florida's design and engineering societies, plus one layman. The position of jury chairman rotates annually among the deans of Florida's three schools of architecture.

Governor's Design Award winners are not always buildings. A bridge over a state road in Sarasota County won a 1983 award, according to the St. Petersburg *Times*, for its "clean, low-profile design." A vaudeville-theater restoration project, carried out by the city of Pensacola and the University of West Florida, was a 1984 winner, along with a downtown redevelopment project in North Miami, and a native-stone visitor center at a state park near Micanopy, Florida.

Boston: 'A City Upon a Hill' Ponders its Livability

As Webb Nichols tells it, the seed for the Boston Conference — that city's wide-ranging and remarkable examination, during 1984, of development in its downtown and neighborhoods — was planted during a slide show at the Boston *Globe*.

"Boston's downtown development in the past twenty years has been explosive. In this short period of time . . . the architectural fabric of Boston has been transformed. This development, in the opinion of design professionals and the public at large, has been undertaken without enough regard to the needs of citizens for a better city environment."

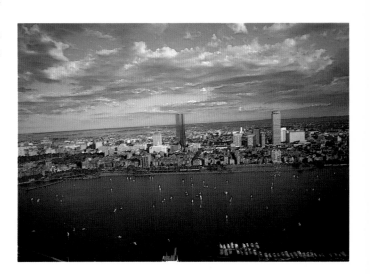

Sunday boaters cruise the Charles, with Boston for their backdrop.

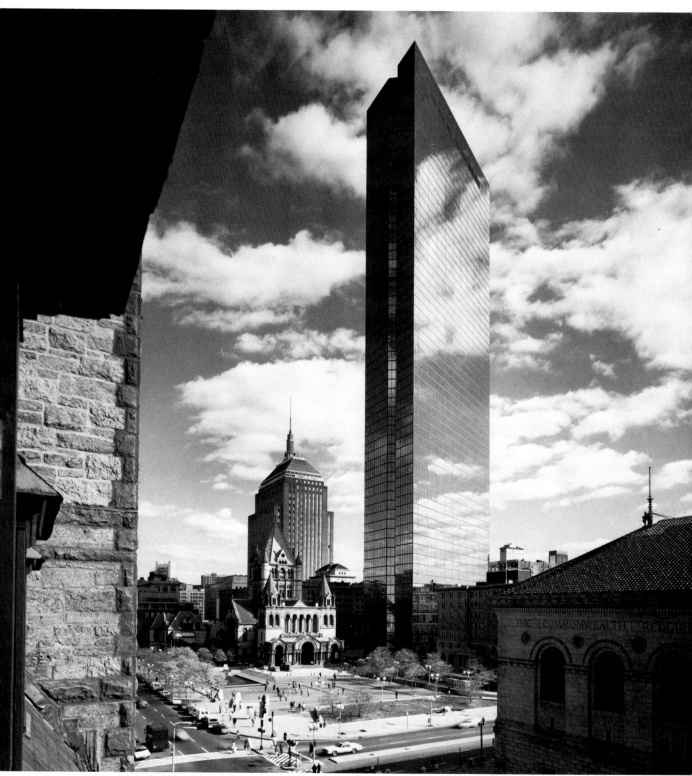

Present shock: Its glass sheath
reflecting the clouds over Copley
Square, the John Hancock Building
towers above Trinity Church.
Opposite, old Faneuil Hall.

A Cambridge, Massachusetts, architect, Nichols has expressed his worries about Boston development, and about the danger of losing the city's "spirit of place nurtured over three centuries," in the opinion pages of the *Globe*. Invited in early 1983 to discuss architecture and development for *Globe* editors, he decided to present a slide-show "walking tour" of the city. During his presentation, Nichols projected two slides, one of downtown Boston, the other of downtown Los Angeles. "And the editors, who are pretty sensitive people, couldn't tell which was which," recalls Nichols. Later, he met with Thomas Winship, the newspaper's chief editor, and suggested having "someone from the outside come in here and evaluate the city for those of us who can't see the forest for the trees."

"I was concerned about Boston. I'd lived here since 1967, and there seemed to be a great difference between the city one fantasizes about — the 'walking city,' Back Bay, cobblestones — and the city as it is. My intuition was that the city was being overbuilt and the quality of some of the work was inferior." An advantage of bringing in hired architectural guns to analyze the city, he says, is that "they've got no vested interest. They're not going to get any projects from the city."

Ultimately, "Boston: A City and Its Future" took shape as a collaborative effort of the *Globe* and the Massachusetts Institute of Technology, with the four-part conference designed, managed, and staffed as a research project of MIT's Laboratory of Architecture and Planning.

During the first, fact-finding phase of the conference, nationally known experts in architecture and planning were brought to the city to hear from public officials, developers, and other Bostonians who have contributed to the city's physical transformation. The experts attended hearings at three sites in different areas of Boston, as well as a day-long, wrap-up session at Faneuil Hall. At that final session, the visiting experts presented their findings to an audience of citizens and city officials.

> **"There seemed to be a great difference between the city one fantasizes about—the 'walking city,' Back Bay, cobblestones—and the city as it is. My intuition was that the city was being overbuilt and the quality of some of the work was inferior."**

The conference format is now a tool that can be used by other cities confronting development issues. "We believe the model is replicable."

"Tying the conference to an accountable set of facts about geographic areas of the city" was a major contribution of MIT's Laboratory of Architecture and Planning, says Thomas Piper, principal research scientist at the lab and the conference's project director. Lab staff designed the series of three community-based workshops — what Piper calls "a moveable feast" — that focused on city areas subject to differing development pressures.

The first area chosen for study — downtown extending to the waterfront — shows the concentrated effects of large-scale development that began in Boston in the late 1950s. The second study area, Washington Street from Chinatown to Roxbury, links two inner-Boston neighborhoods that have benefited little from the city's building boom. Copley Square, the third area, combines aspects of the first two study sites, according to an MIT newsletter, "as the place where the affluent commercial spine of Back Bay, extending from the downtown area, meets the economically mixed neighborhood of the South End, many of whose residents have experienced or are threatened by displacement."

Each city section was described in detailed case studies prepared by MIT research staff. "The case studies were actually briefing documents for the local as well as the national panelists," says Piper. Those local panelists, who gave presentations at workshops and who took questions from the public and the invited national experts, included more than two dozen officials, developers, design professionals, and community representatives.

For its part, the *Globe* provided extensive daily coverage of the spring 1984 workshops and of the wrap-up conference at Faneuil Hall. In November 1984, the newspaper also published a 48-page magazine supplement on the conference and issues it raised. Titled "The Livable City?" the supplement was intended, according to the *Globe*, "to further and to focus the debate" on Boston development.

At the heart of that debate is the fear that the city's downtown has been developed without regard for civic

needs, that despite projects that are the envy of other cities, much of Boston's building has failed to produce a substantially better public city.

"Boston's downtown development in the past twenty years has been explosive," *Globe* editor Winship wrote in a pre-conference letter. "In this short period of time, under the leadership of political administrators committed to city growth, the architectural fabric of Boston has been transformed. This development, in the opinion of design professionals and the public at large, has been undertaken without enough regard to the needs of citizens for a better city environment. The massive construction program has also raised the question of social equity, as the downtown appears to be prospering in an era of declining Boston neighborhoods."

The five national experts invited by the *Globe* and MIT to participate in the Boston Conference included: J. Max Bond, Jr., chairman of Columbia University's Graduate School of Architecture and Planning; Dolores Hayden, professor of architecture and planning at the University of California, Los Angeles; Allan B. Jacobs, professor of city and regional planning, University of California, Berkeley; Moon Landrieu, former mayor of New Orleans and secretary of Housing and Urban Development during the Carter Administration; and Barton Myers, professor of architecture at UCLA.

At Faneuil Hall on May 12, 1984, the panelists offered a variety of prescriptions and observations. Allan Jacobs urged the city to devise a new master plan, lest future development be left to the "whims of chance."

Barton Myers saw Boston in danger of becoming a typical "unicentered North American city, with its radically high-density, high-rise downtown core, with its sprawling, radically low peripheral areas." Moon Landrieu, on the other hand, defended tall buildings: "I don't find working on the fortieth floor of a high-rise inferior to working in a sweatshop in the basement of a building of human scale."

Was the conference a success? "A very valuable standard-setting exercise, a consciousness-raising exer-

"For we must consider that we shall be a city upon a hill. The eyes of all people are upon us."

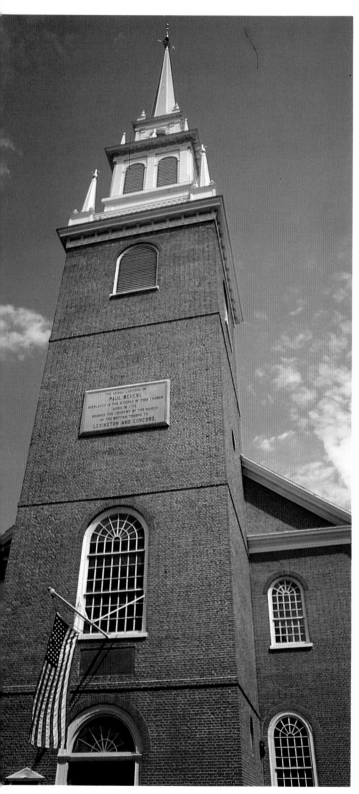

Spirit of place: On an April night in 1775, Paul Revere saw the lantern in Christ Church's lofty steeple, and rode off to rouse the minute men.

cise," is how John de Monchaux, dean of MIT's School of Architecture and Planning, summed it up. "The chief purpose was to inform the debate that would shape Boston. I think in the broadest sense it did that," he says, adding, however, that only the next half-dozen years of city development will begin to tell the tale.

To Thomas Piper, of the MIT Laboratory of Architecture and Planning, the conference format is now a tool that can be used by other cities confronting development issues. "We believe the model is replicable," he says, provided "you can bring in one of these powerful communications technologies, a newspaper or a television station," and provided a city has the services of "a broker like MIT."

Webb Nichols, the architect who proposed the conference, gives Boston's 1984 debate on development mixed marks. "We still really don't have a consensus of how the city should go," he says. At the three local forums and at the Faneuil Hall wrap-up, "it was difficult for people to hold on to a discussion of how Boston is being built." In a city with social and economic tensions, "the more one seemed preoccupied with that, the more it seemed an elitist preoccupation."

Yet as a result of the conference, says Nichols, "I think there *has* been a sensitivity toward building now in Boston." And he believes that public forums and newspaper coverage that focus on urban design, thus creating citizens informed about architecture and development, "can help prevent bad work from taking place."

The *Globe*, in its special conference supplement, reminded readers of testimony from an old Boston hand: "For we must consider that we shall be a city upon a hill. The eyes of all people are upon us," John Winthrop, governor of the Massachusetts Bay Colony, told New England-bound Puritans in 1630.

In later days, said the newspaper, descendants of those first Bostonians had "leveled the hills and pushed them into the sea to create the Back Bay, the South End, and other wonders of urban elegance In the late 20th and into the 21st century, Bostonians must decide how

to control and enhance their environment In addressing the civic design of this prosperous, handsome, widely admired, world-class city, John Winthrop's warning," suggested the newspaper, was "worth recalling."

Escondido: Staging a Competition to Focus the City's Vision

"The idea," says Rod Wood, assistant city manager of Escondido, California, "was to set a trend for excellence in architecture." The problem, he says, was that when people tried to visualize Escondido's badly needed new civic/cultural center — the acknowledged starting point for local architectural excellence — that the downtown complex should look "nice" was all anyone could agree on.

"Everybody in the community knew we wanted an architectural masterpiece — within the budget," says Wood. "But no one could visualize what that building would look like. Ninety-five percent of the reason we went with a design competition is we didn't specifically know what we wanted."

Escondido officials did know a new civic center would fulfill three major needs — providing government office space, a center for conferences and meetings, and a cultural facility for the performing and fine arts. For the city of 72,000 people, situated thirty miles northeast of San Diego, the civic center also represented a way to insure Escondido's role as a leader in northern San Diego County.

For Escondido, and for architects invited to participate, the city's 1984 design competition posed a unique opportunity to devise a development scheme for an entire downtown block in a fast-growing southern California community. According to Rod Wood, the city also hoped its competition would attract national attention to the city's proposed $52-million construction project, thus increasing Escondido's chances of obtaining corporate and foundation funds to support civic-

"Ninety-five percent of the reason we went with a design competition is we didn't specifically know what we wanted....The idea was to set a trend for excellence in architecture."

center cultural programs. As Wood points out, "It's very difficult to ask somebody for $100,000 for a project they've never heard of."

The two-stage urban design competition was partly financed with funds from the Design Arts Program of the National Endowment for the Arts. Escondido advertised its competition nationally, to attract a wide range of entrants and to provide younger architects the opportunity to compete with well-established firms. Further, the city agreed to pay a $7,500 honorarium to each of five design-team finalists, and an additional $10,000 prize to the competition winner.

The eleven-member jury for the seven-month competition included professional designers and architects and Escondido city officials and residents. In an important sense, however, all of Escondido helped judge the contest.

"We opened up the first and second stage of this competition to the public to get comments," says Rod Wood. "In the first phase [when 108 architects submitted proposals] we had over 1,500 citizens make comments. They were all typed up and presented to the jury."

During the second stage of the competition — when five finalists refined their submissions — the city aired a twenty-minute cable television program that presented the top designs and further explained the city's civic-center plans. Viewers were given an address to which they could send comments. Also, a local newspaper published photographs of finalists' designs and provided information about the civic center. The purpose of the public polling, says Wood, was not to pick the winner of the competition (the jury would do that), but to help jury members gauge public taste in the diverse community.

The jury's unanimous choice for the winning civic-center design came from Pacific Associates Planners & Architects, of San Diego, whose plan featured a welcoming city-hall entrance, lattice-covered arcades, intimate courtyards, and a chime tower above a reflecting pool.

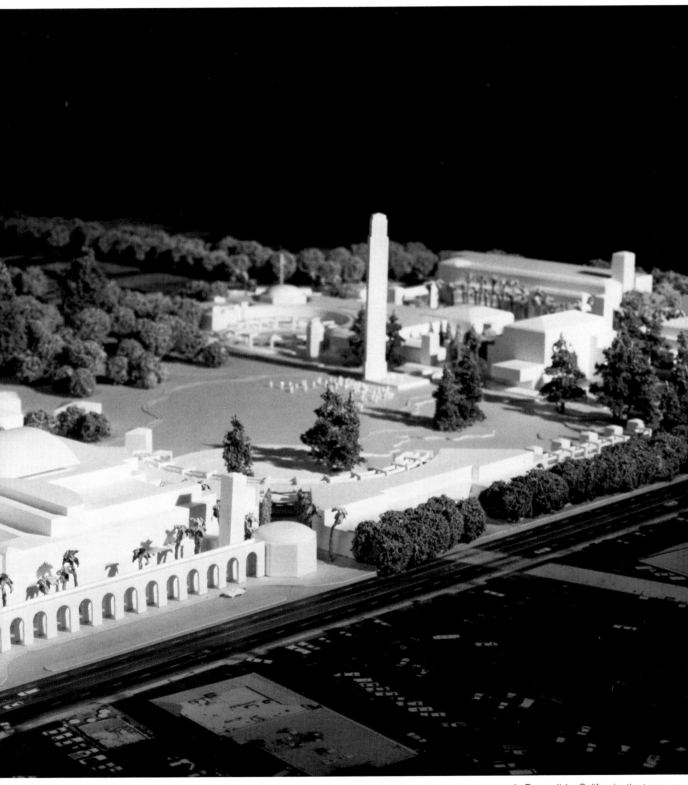

In Escondido, California, the town solicited comments from citizens to help an eleven-member jury select the winning entry (above) for a new downtown civic/cultural center.

Pacific Associates Planners & Architects proposed the scheme (above) that Escondido hopes will set a trend for excellence in architecture.

"The jurors were impressed," William Liskamm, a San Rafael architect and the competition's professional adviser, told the Los Angeles *Times*, "because the design captured a sense of spirit."

Escondido's official assessment of the design competition that yielded a city's vision for architectural excellence may have been best expressed by Mayor Ernie Cowan. "I'm so excited," said the mayor when the winner was announced, "I want to run out tomorrow and start building it."

Los Angeles: Culture as Cure for MacArthur Park

Like a foster parent taking on a troubled but promising child, the Otis Art Institute of Parsons School of Design has "adopted" MacArthur Park in Los Angeles, with the intention of molding a thicket of crime into a place as art.

"The goal of this program is to give MacArthur Park a new identity," says Al Nodal, director of exhibitions at Otis/Parsons. "Right now, the identity is crime. You say 'MacArthur Park' and people shudder. We're trying

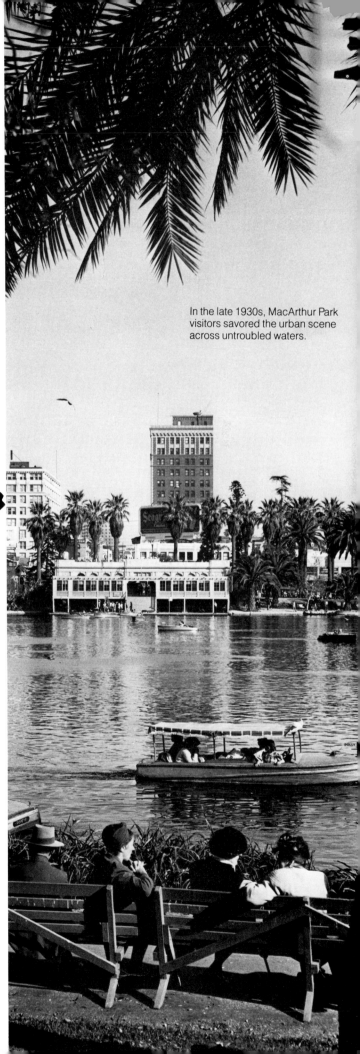

In the late 1930s, MacArthur Park visitors savored the urban scene across untroubled waters.

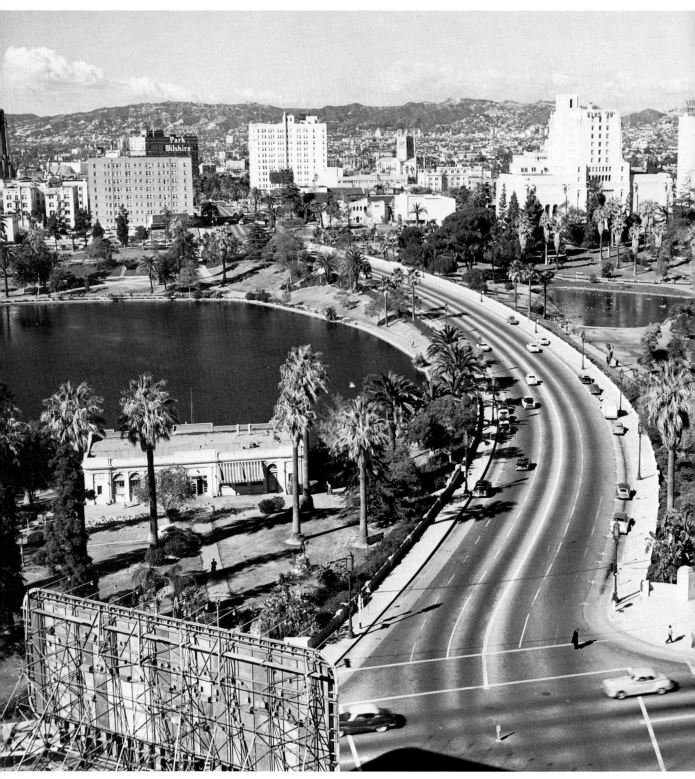

MacArthur Park around 1940,
looking toward the Hollywood Hills.
Low, white buildings at the park's
edge, where Wilshire Boulevard
intersects the park, house the Otis
Art Institute.

to change the identity to art." For Nodal, and for art, that qualifies as a tall order.

"In all of Los Angeles, there may be no other gathering place quite like MacArthur Park, centerpiece of the city's most crowded neighborhood, one of its most bustling and varied, and one of its poorest," reported the Los Angeles *Times*. Once a park "for daytime strolling, evening dances, plays and other activities befitting its affluent surroundings," MacArthur declined over the years, becoming "a haven for the unemployed, winos, and other homeless wanderers," and, after dark, a staging ground for "dope dealers and those who prey on the weak." Elderly neighborhood residents, said the *Times*, "remember the old days in the park but now avoid it as if it were a swamp."

Nodal, who is directing the Otis/Parsons program to reshape the park, sees the thirty-two-acre site as something more — a potential "urban laboratory" in which to "demonstrate the potency of creative approaches and fresh thinking toward complicated urban issues."

"We want to understand and build upon the park's character," Nodal told the Los Angeles *Herald Examiner*. "What we want to avoid like the plague is any sense of highbrows imposing clever ideas on a passive public. We're talking to everyone we can around here, generating interest where there was only despair, focusing energy where official initiatives fail."

Art may prove the salvation of MacArthur Park, but crime and cleanliness are of more immediate concern to the neighborhood. Thus, Nodal has worked at community organizing as well as at arts planning. Through the new MacArthur Park Community Council, Nodal has obtained public and private funds for the Otis/Parsons art program, as well as the backing of the Los Angeles Police Department and the city's Recreation-and-Parks and Cultural-Affairs Commissions. In October 1984, Nodal and the community council's chairman, a local hotel owner, called the first meeting of a "Business Watch" group. An organizing session for the neighborhood's first community crime-watch program, the meeting was attended by more than one hundred local

"The goal of this program is to give MacArthur Park a new identity. Right now, the identity is crime We're trying to change the identity to art."

"We want to understand and build upon the park's character. What we want to avoid like the plague is any sense of highbrows imposing clever ideas on a passive public."

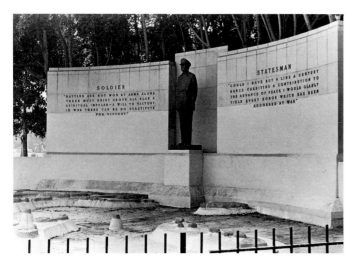

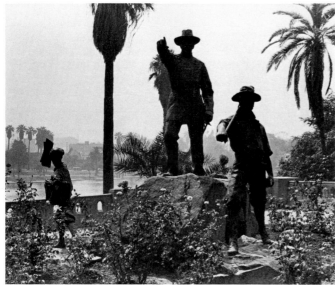

Men of MacArthur: In 1942, the park was named after General Douglas MacArthur (statue at top). "The Otis Group" honors the founder of the Los Angeles *Times*. Al Nodal, of Otis/Parsons, sees the park as an urban laboratory for curing with culture.

merchants. The community council has also formed a beautification committee to oversee MacArthur Park trash clean-up efforts. The council's public-affairs committee has been given the task of winning favorable press coverage for community efforts.

Meanwhile, Nodal is pushing forward with the MacArthur Park cultural program. Phase I, in early 1984, and "designed," says Nodal, "to introduce a more visible cultural presence in . . . the community and to initiate interest in a program of public art," brought the creation of three temporary public art works and two semi-permanent sculptures by Los Angeles artists. The art works — partly intended as a means for testing local waters — were installed on the Wilshire Boulevard frontage of Otis/Parsons, directly overlooking the park.

During Phase II, in late 1984, a national committee of artists and public-art experts gauged community reaction to the first five art works, surveyed sites for future MacArthur Park art, and selected artists for Phase III of the program. Those Phase III artists, after meetings with neighborhood residents, were expected to create (on site in MacArthur Park) up to ten works of art that would be maintained by Otis/Parsons. Finally, during Phase IV of the visual-arts program, in late 1985, a permanent work of neon art was to be created for the exterior of the Otis/Parsons Exhibition Center on Wilshire Boulevard.

In conjunction with the visual-arts program, Otis/Parsons has planned a design-demonstration project, featuring Los Angeles designers and artists, to develop an overall plan for architecturally and functionally refurbishing the long-neglected city park.

"The mandate of this team will be to build on the park's character to create an urban place that is expressive of its traditions, aspirations, and values," reports Otis/Parsons. "Elements of the plan [to be presented to the community in a fall 1986 exhibition and symposium] will include general lighting in the park, the lighting of specific art works and existing monuments, and the refurbishing of the General Douglas MacArthur monument Proposals for improving MacArthur Park

Bandshell, converting the currently defunct Senior Citizens Center into a working arts and crafts facility, and for the renovation of other existing structures in the park, such as the boathouse, food concessions, and bathrooms, will be developed. Seating, walkways, and landscaping will also be treated."

Meanwhile, while the sculptors sculpt and the designers design, an Otis/Parsons performing-arts advisory committee will help arrange six MacArthur Park mini-festivals of dance, opera, theater, music, comedy, and folklore to be presented free in the park during 1985 and 1986.

Adoption, of course, is forever, and even an arts program as ambitious as Otis/Parsons' should offer continuing hope, not just a short-term diversion from community problems. To that end, Nodal and Otis/Parsons have prepared plans to evaluate the MacArthur program and to develop criteria for continuing it.

"Can Al Nodal and his group overcome the old indifference of Angelenos to their public spaces?" asked the Los Angeles *Herald Examiner* in an article on the MacArthur Park art program. "Can [Nodal] learn to walk upon the water?"

Nodal would seem to think so. His faith in the possibility of remaking places with art is great. "Artists," he believes, "are capable of providing the leadership needed to revitalize a community." He also hopes other cities will be encouraged to study Otis/Parsons' efforts as a guide to reshaping their own troubled urban spaces into places as art.

"We feel artists can come in with a fresh approach," he says, "using culture, using art, to give a community a new focus. We're trying to do that for this neighborhood, which hasn't had a focus, which has been blighted over the years. We're hoping this program will be the first model for that sort of approach, which can then be tried elsewhere."

●

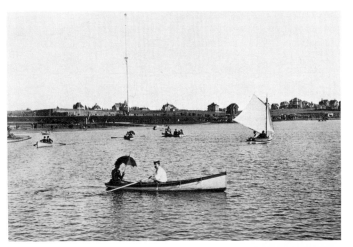

Angelenos rowed their boats at the park in the early years of this century, relaxed on shore during the 1940s, attended drawing class in the 1950s.

In Columbus, Irwin Union Bank &
Trust addition was designed by
Kevin Roche John Dinkeloo &
Associates, completed in 1973.

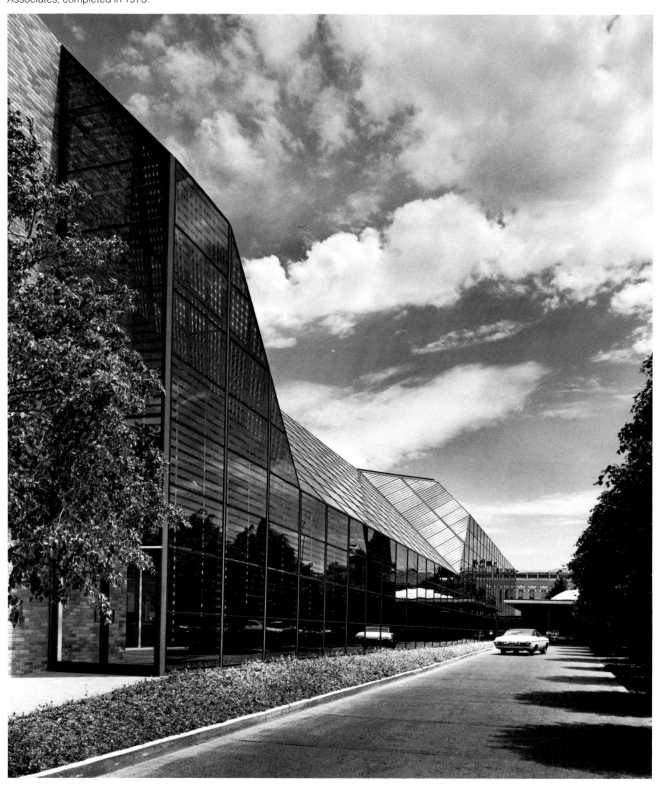

*"We're third in the nation
with buildings by famous
contemporary architects—
forty-seven now and three
on the drawing boards."*

Columbus: Corporate Support for Prairie Architecture

"It's a delight to be mayor of Columbus, Indiana," says Robert Stewart. The Columbus native and first-term mayor mentions the excellence of his city's schools and cultural activities as two reasons Columbus ranks as more than "just another typical Midwestern community."

But treasures of stone, and steel, and glass — the notable buildings that have gone up in Columbus since the 1940s — are what draw some 50,000 sightseers a year to the town, and are what have earned Columbus the title of "Athens on the Prairie."

"We're third in the nation," Stewart says of the city, "with buildings by famous contemporary architects — forty-seven now and three on the drawing boards." Given Columbus' size (population 30,000), the town almost certainly qualifies, as the Chamber of Commerce likes to point out. as "the most concentrated collection of contemporary architecture in the world."

"On Sundays, the citizens of Columbus worship in churches designed by Eero and Eliel Saarinen," reported *Time* magazine in 1977. "They borrow books at a library built from the innovative plans of I.M. Pei and embellished with a bronze arch sculpted by Henry Moore. They shop in a glass-enclosed piazza designed by Cesar Pelli, and send their children to schools conceived by architects Harry Weese, Eliot Noyes, and John Warnecke."

Eliel Saarinen's First Christian Church, completed in 1942, is the oldest of Columbus' contemporary architectural treasures. Saarinen was commissioned as architect at the urging of J. Irwin Miller, a Columbus industrialist who has been dubbed "the Medici of the Midwest." Miller, 76, is chairman of the executive and finance committee of Cummins Engine Company. The company, with headquarters in Columbus, manufactures diesel truck engines and employs 9,000 people in the Columbus area.

Built treasures draw students and lay enthusiasts of architecture to Columbus, Indiana, where a Cummins Engine Company program has paid design fees for schools and other public structures.

Architectural excellence has "brought a quality of life into this little community which otherwise would have been unattainable."

The Columbus Fire Department's Station No. 4, built in 1967, was designed by Venturi & Rauch.

In the mid-1950s, after he had become board chairman at Cummins, Miller further nudged his hometown toward architectural excellence when he announced that the newly formed Cummins Engine Foundation would pay design fees for new public schools in Columbus.

"This was the period when the baby-boomers were entering school," says Ann Smith, public-information manager at Cummins Engine. "Columbus had built no new schools since the 1920s, and there was a need for a number of schools to be put up quickly."

Other city agencies have since taken advantage of the Cummins Foundation architecture program. Foundation guidelines stipulate that the public governing board responsible for construction choose its architect from a list of first-rank American designers. The list must be compiled by "a disinterested panel of two of the country's most distinguished architects." Architects chosen by a city agency must also be ones not previously selected for Cummins-supported projects. As of late 1983, the Cummins Foundation had spent more than $8 million on the architecture program.

"Cummins has handled this whole thing very adroitly," says Robert Brown, owner and publisher of the Columbus *Republic* newspaper. "The architects for these buildings are not selected by Cummins. An architect who has done a building doesn't get back on the list. Cummins pays the architect without any restriction on the size of the building, the design of the building. It's just about as hands-off a program as there can be."

In 1957, the Lillian C. Schmitt Elementary School, designed by Chicago architect Harry Weese, became the first public building to result from the Cummins program. In all, a dozen schools have been built with architectural fees paid by Cummins. Other Cummins-supported public buildings in Columbus include a fire station, a regional mental health center, the city hall, and the Columbus Post Office, which is the first United States post office to be designed by privately paid architects.

J. Irwin Miller and Cummins Engine have set the pace

for fine architecture in Columbus. But other public and private structures have been designed by well-known architects without Cummins' assistance. "We've been fortunate," says Mayor Stewart. The town's renowned architecture has brought its own benefits, he says. "We've never made any campaign to attract visitors," but they still pour in — lay enthusiasts of design by ones and twos and architecture students by the busload. The town's famous contemporary architecture has also encouraged citizens to preserve and restore the community's fine old architecture. According to the Columbus Area Chamber of Commerce, downtown merchants cooperated several years ago "in storefront repainting and new signage for a 'model block' [designed by architect Alexander Girard] between Fifth and Sixth Streets on Washington Street Since then many downtown area owners have followed the master plan to rejuvenate the typical Midwestern nineteenth-century buildings."

"It's brought a quality of life into this little community which otherwise would have been unattainable," Robert Brown says of his city's devotion to architectural excellence. "It's encouraged other people to do things they might not otherwise have done. A case in point," says the publisher of the *Republic*, "is our newspaper building." The *Republic* plant, designed by Skidmore, Owings & Merrill, won a 1975 honor award from the American Institute of Architects. "We wanted to do something that was compatible with the community," explains Brown. "There's a certain amount of peer pressure. When people do something horrible [in terms of design] letters are written to the newspaper complaining."

Of course, even the most artful architecture must succeed as shelter. Fortunately, the treasures of Columbus do just that. "They are places to learn in, pray in, read in, have fun in, work in, bank in, have the daily life of the community written and printed in," reported *National Geographic*. "Small town in scale," the magazine said of the buildings of Athens on the Prairie, "they fit in like slightly eccentric neighbors, adding variety, provoking debate, and stimulating a taste for the unconventional."

The 1964 North Christian Church was the last building designed by architect Eero Saarinen.

SHOWCASE PLACES

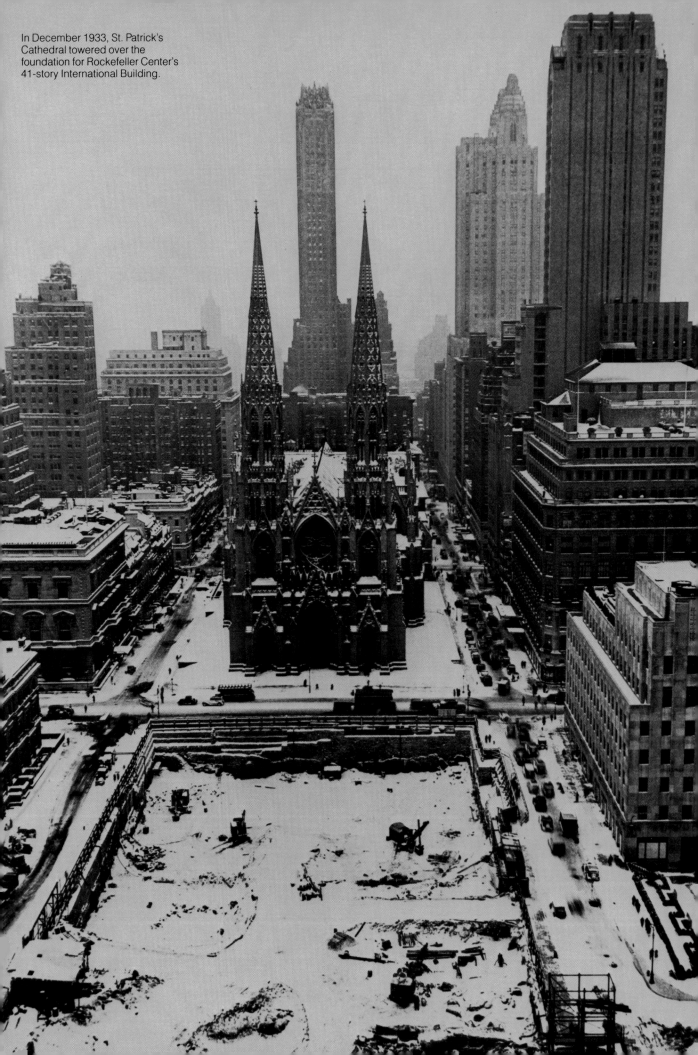

In December 1933, St. Patrick's Cathedral towered over the foundation for Rockefeller Center's 41-story International Building.

ROCKEFELLER CENTER

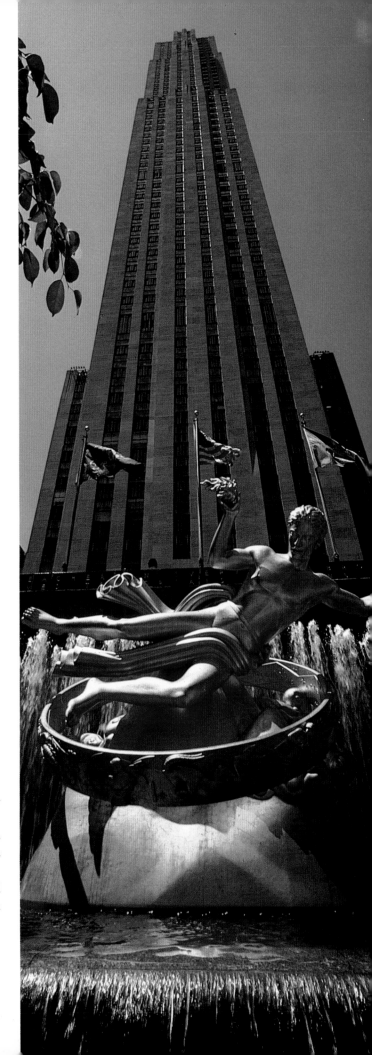

Nineteen buildings in a city studded with notable architecture, Rockefeller Center is one of America's classic urban spaces, a city-within-a-city that, according to a 1939 guidebook, "stands as distinctively for New York as the Louvre stands for Paris."

Designed quickly, by a crew of architects, the complex expresses a degree of integrity that generally appears only in single structures created slowly and in solitude. "It is a feat of mingled inspiration and accommodation that architectural historians will go on pondering for as long as the Center stands," wrote Brendan Gill.

In the 1920s, the midtown site where Rockefeller Center now stands was occupied by bordellos and speakeasies. A new opera house was proposed as a suitable replacement for the low-toned neighborhood, and financial backing from John D. Rockefeller, Jr., was secured for the project. The stock market crashed a year later, and the opera house plan was scrapped. Rockefeller, however, still held the lease for three expensive blocks of Manhattan. A new plan was developed for a skyscraper complex that would stand as an example for future urban planning.

"Wasteful," "undistinguished," and "inartistic" were just a few of the criticisms hurled at the scheme before construction began. By 1938, when the Center was nearly complete, New Yorkers had grown more enthusiastic about Rockefeller's addition to the urban landscape. "This is the Future," said social historian Frederick Lewis Allen.

In a city of superlatives, Rockefeller Center set new standards for greatness. The 850-foot RCA Building, nicknamed the "Slab," was not only one of New York's tallest skyscrapers; in gross space, it was the world's largest office building. Inside Radio City Music Hall, where ticket prices began at 40¢, New Yorkers could wonder at the golden proscenium arch, its 300-ton

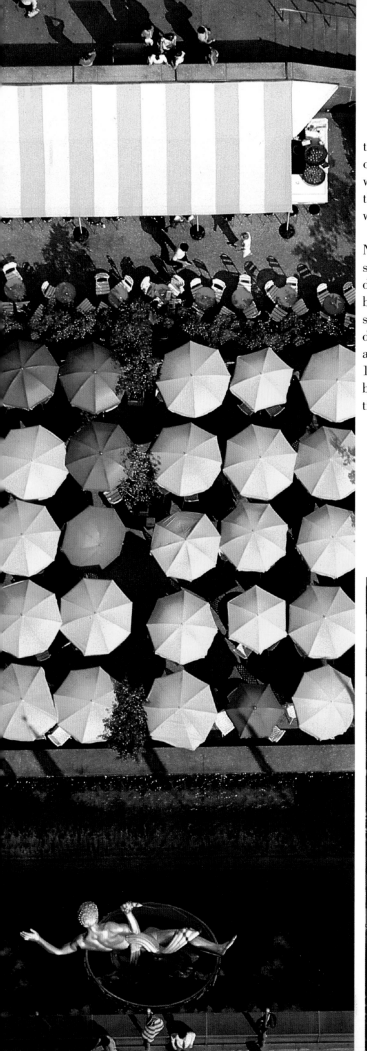

truss the heaviest that had been used in a theater. They could listen to the world's largest theater orchestra, and watch films on the world's largest movie screen. When the Rockettes came on stage, the audience enjoyed the world's longest line of precision dancers.

Nowadays, Rockefeller Center is admired less for its size than for the intelligence with which it was designed. Walking among the Center's towers, one becomes conscious of relationships between individual structures. Different spaces between buildings, and differing heights and circulation patterns, blend to form a coherent whole. The creation that Lewis Mumford, in 1940, called "architecturally the most exciting mass of buildings in the city" is a vision of the future that continues to inspire.

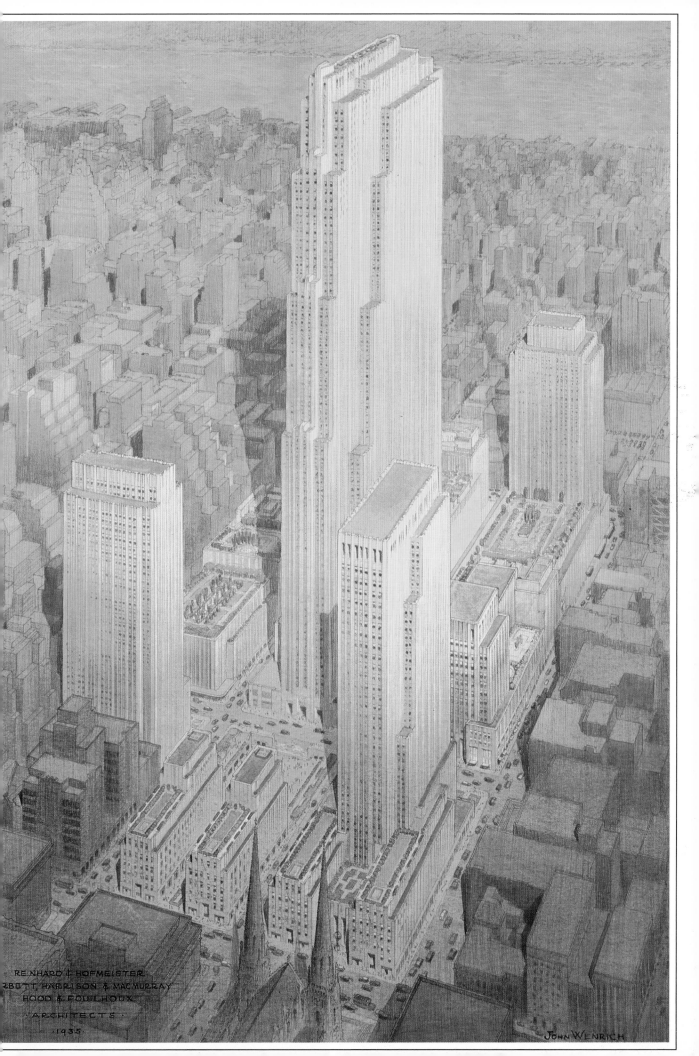

REINHARD & HOFMEISTER
CBETT, HARRISON & MACMURRAY
HOOD & FOUILHOUX
·ARCHITECTS·
·1935·

JOHN WENRICH

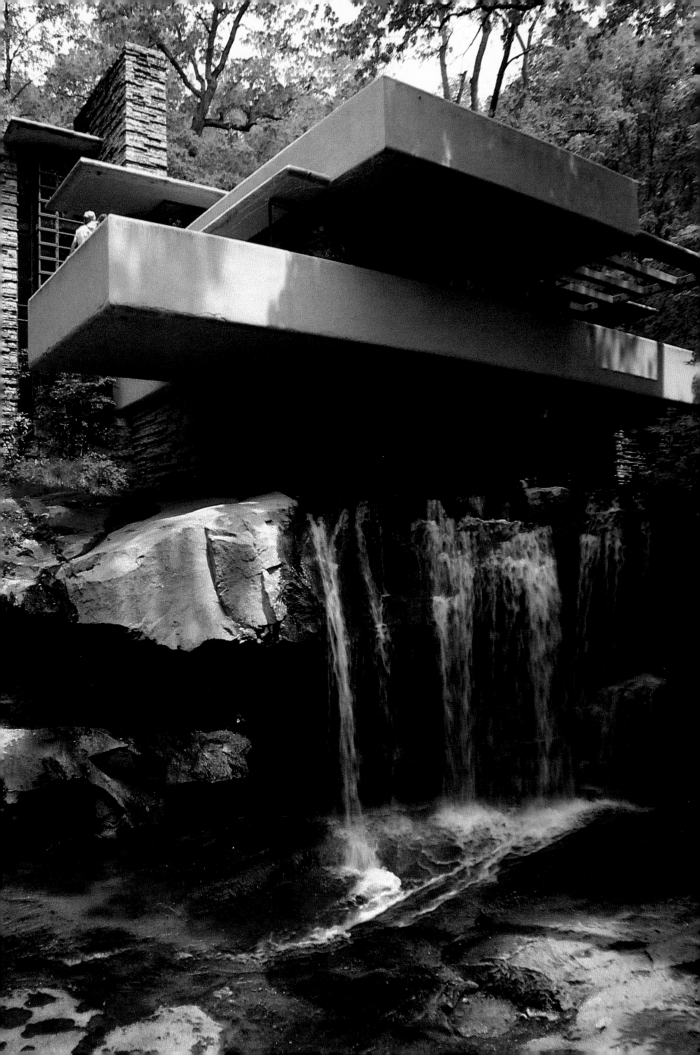

FALLINGWATER

Frank Lloyd Wright's Fallingwater, a house cantilevered over a waterfall on a forested site in the Bear Run Valley of Pennsylvania, was designed in 1935, when the architect was sixty-eight years old, and in the fourth decade of his career.

For Wright, the house in the woods came at something just short of midpoint, wrote Tom Wolfe, in "the most prodigious outpouring of work in the history of American architecture."

"In the next twenty-three years, until his death at the age of ninety-one in 1959, he did more than half of his life's work, more than 180 buildings, including the Johnson Wax headquarters in Racine, Wisconsin; Herbert F. Johnson's mansion, Wingspread; Taliesin West; the Florida Southern campus; the Usonian homes; the Price Company tower; and the Guggenheim Museum."

Wright designed Fallingwater for Edgar J. Kaufmann, Sr., a Pittsburgh department store owner and the father of one of the architect's apprentices. Although an admirer of Wright, Kaufmann was surprised by his first sketches for the house, having imagined that his country retreat would be near, but not necessarily over, the water. "E.J., I want you to live with the waterfall, not just to look at it," Wright told Kaufmann.

As conceived by Wright, the house would be formed of concrete terraces that echoed the rock ledges of the landscape. To support a house that, in Wright's words, came "leaping out" over the falls, the architect relied on cantilever beams of reinforced concrete. Vertical planes of sandstone, quarried on the site, separate the horizontal concrete terraces. The rock ledge beneath the house penetrates the living-room floor, forming the hearth.

Years later, speaking of the house and of the man for whom he designed it, Wright said, "I think you can hear the waterfall when you look at the design. At least it is there, and he lives intimately with the thing he loves."

●

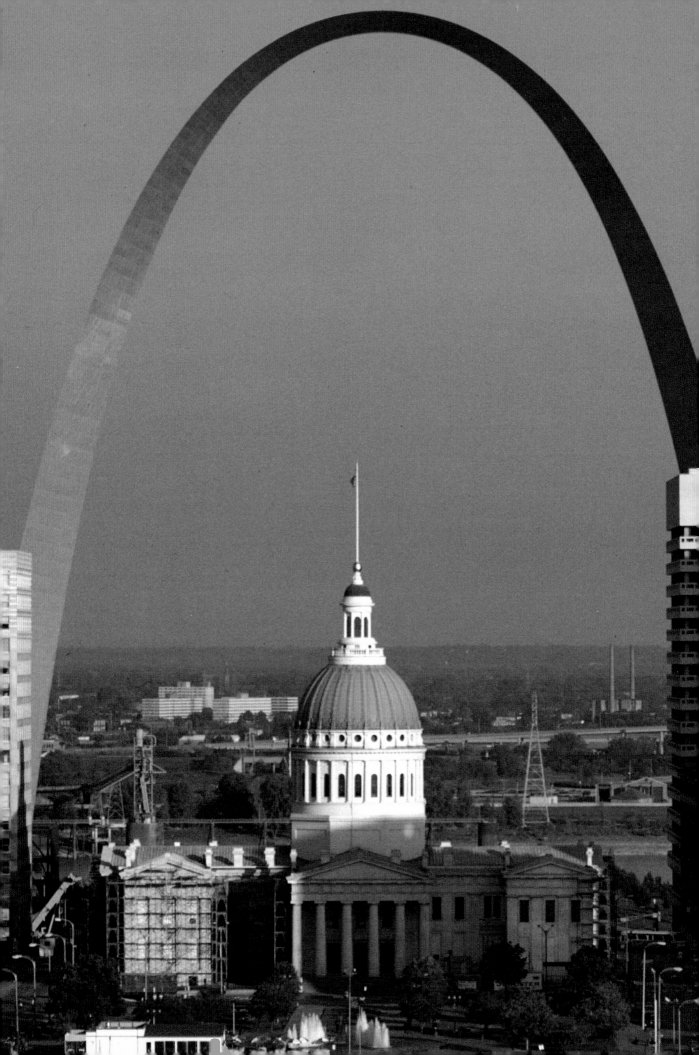

GATEWAY ARCH

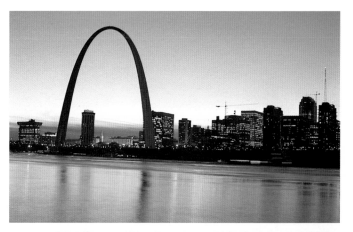

"I was trying," Eero Saarinen said of his design for the Gateway Arch in St. Louis, "to reach for an absolutely permanent form — a high form."

A slender hoop rising 630 feet above a bluff along the Mississippi River, the Gateway Arch is our tallest monument. Known officially as the Jefferson National Expansion Memorial, the arch honors our third president and commemorates America's westward growth. It was also intended, in Saarinen's words, as "a triumphal arch for our age as the triumphal arches of classical antiquity were for theirs."

Son of the Finnish architect Eliel Saarinen, the younger Saarinen designed the United States Embassy in London, the Trans World Airlines terminal at Kennedy Airport, and the Dulles Airport building outside Washington, D.C. But it was his plan for a stainless-steel arch on the Mississippi — first prize winner in a 1948 design competition that both Saarinens entered separately — that brought the son independent notice. Eero Saarinen died in 1961, more than a year before assembly of the Gateway Arch got underway, and seven years before it was dedicated.

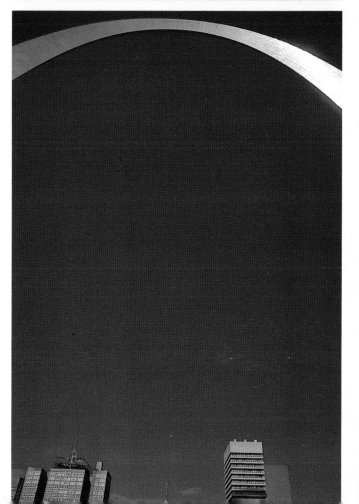

Composed of an inner skin of carbon steel and an outer one of polished stainless steel, the arch is a catenary curve, measuring the same distance from ground to crest as it does from extrados to extrados.

For Saarinen, creating the proper memorial involved more than selecting an appropriate sculptural form. He also worked to integrate the intentions of the monument with the site.

"The arch was placed near the Mississippi River, where it would have most significance," he said of his design in 1959. "Here it could make a strong axial relation with the handsome, historic Old Courthouse which it frames. Here, from its summit, the public could confront the magnificent river . . . All the lines of the site plan, including the paths and the roads, and even the railroad tunnels, have been brought into the same family of curves to which the great arch itself belongs."

●

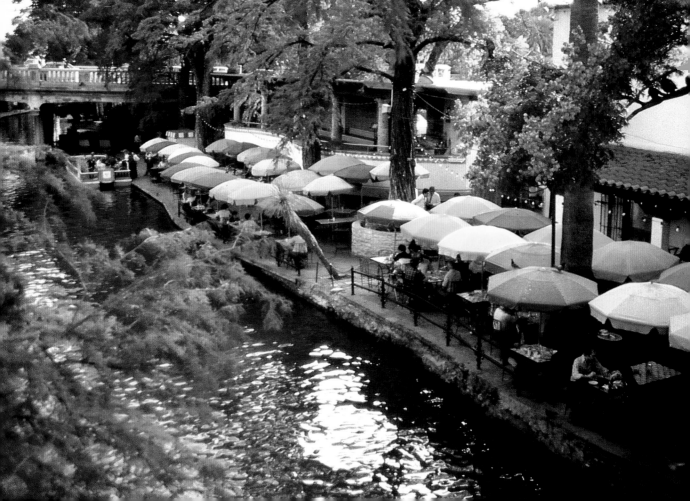

PASEO DEL RIO

One level down from the busy streets of the city, San Antonio's Paseo del Rio has been described, in the *AIA Journal*, as "a linear paradise of infinitely changing vistas . . . animated by the presence of buildings, shops, restaurants, and people."

There was a time when San Antonio's ten miles of river corridor seemed quite the opposite of paradise. After the flood of 1920 raised the waters 35 feet above normal, there was talk of covering the river for a sewer and converting the space into a major avenue. Four years later, the San Antonio Conservation Society was formed, and by 1937 work had begun — much of it carried out through the Works Progress Administration — to improve rather than bury the river. The WPA project brought stairways, footbridges, plantings and 17,000 feet of river walkway that stretched the length of twenty-one city blocks.

Saved from sewerage, the San Antonio River is now recognized as the city's foremost downtown amenity. The U-shaped Paseo del Rio, a loop in the river with parks, cafes, and esplanades, is a magnet for tourists as well as San Antonio residents. The Paseo is linked to the city's regular street system by bridges and spiral stairs. Tall cypress trees offer vertical scale, and bridges frame distant views. A Texas counterpart to the quais of Paris, San Antonio's river walk is an urban experience unique in America — the sunken, flowing heart of a bustling city.

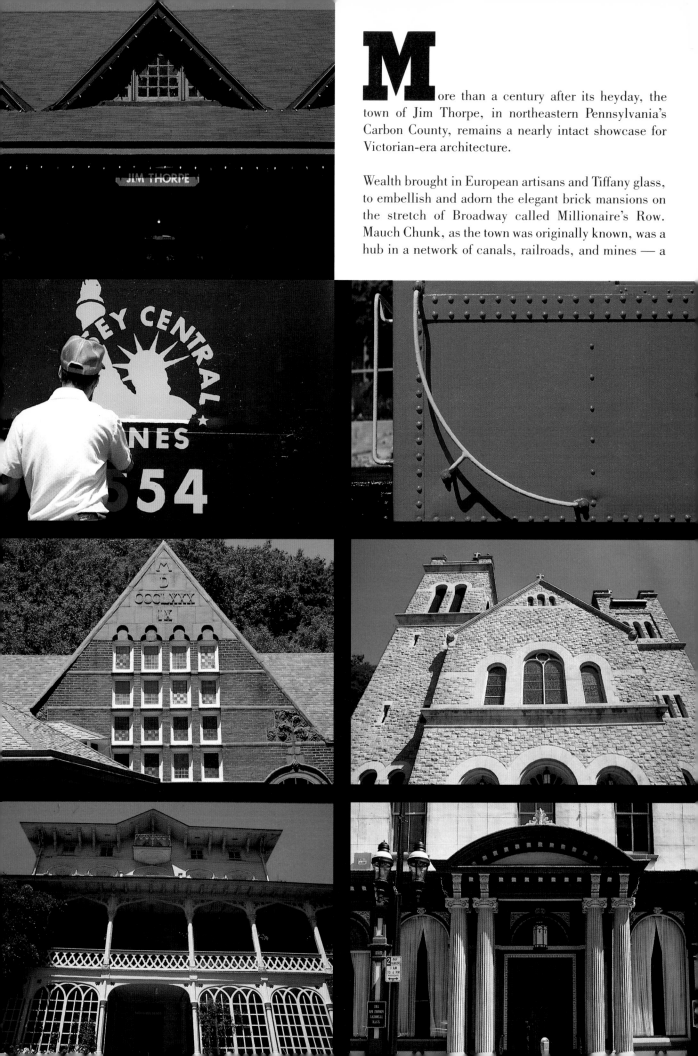

More than a century after its heyday, the town of Jim Thorpe, in northeastern Pennsylvania's Carbon County, remains a nearly intact showcase for Victorian-era architecture.

Wealth brought in European artisans and Tiffany glass, to embellish and adorn the elegant brick mansions on the stretch of Broadway called Millionaire's Row. Mauch Chunk, as the town was originally known, was a hub in a network of canals, railroads, and mines — a

linchpin in the Industrial Revolution. At its capitalist peak, the town is thought to have had more resident millionaires, per capita, than any place in the United States. Asa Packer, one of those millionaires and the founder of the Lehigh Valley Railroad, built an Italianate villa in Mauch Chunk in 1860. He had artisans carve 5,000 rosettes into the mansion's mahogany and walnut paneling.

An 1874 guidebook recommended Mauch Chunk as "the Switzerland of America" and one of the nation's "most noted and popular inland summer resorts." Times changed for the worse, and in hopes of recapturing lost glory Mauch Chunk renamed itself, in the 1950s, after the great Cherokee athlete Jim Thorpe.

Thorpe had never visited Mauch Chunk. But he had first achieved national celebrity as an athlete while attending Carlisle Indian School, 90 miles away. At the suggestion of Thorpe's widow, his body was laid to rest beneath a 20-ton granite tombstone on the east side of town.

In recent years, the town of Jim Thorpe has steered a different, perhaps surer, path toward economic rebirth, using its architectural heritage to attract tourists. Guided walking tours and other ventures have been planned, to cater to visiting fans of architectural Victoriana.

A 1979 study, conducted for the Carbon County Planning Commission by the architectural firm of Venturi, Rauch, and Scott Brown, urged local officials to focus on Jim Thorpe's identity as a "jewel-like town with a proud industrial heritage." The town and its architectural treasures are tightly nestled in a winding valley between mountain walls. "In the interlocking of land with built form . . . Jim Thorpe is utterly unique," noted the study. "It is beautifully, ingeniously and relatively unalterably engaged in a difficult and spectacular site, and remains a place where natural elements [and] form built with nature, to human scale, and expressive of the town's past . . . still remain as the focal features of the landscape."

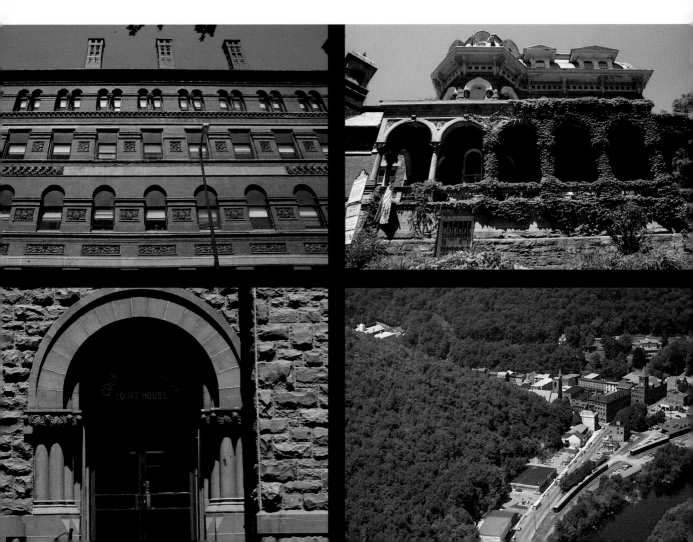

It was called Country Club Plaza back in 1922. Over the decades, it has grown into a retail Brigadoon, with fountains, sculpture, and tree-lined boulevards. There are hotels, condominiums, and more than 150 stores and restaurants. Now known simply as the Plaza, Kansas City, Missouri's shopping city is a 55-acre retort to the idea that one retail complex must resemble another.

If the Plaza represents the shopping-center-as-art, indigenous art it is not. In America's heartland, Plaza managers prefer a Spanish motif of red-tiled roofs, filigree ironwork, and ornate towers. The decorative art — ranging from mermaids to winged steeds, and including a wood-carved Last Supper and a mural of toreadors — also nods toward the Old World.

The Plaza's creator, however, was an American original. Born in Johnson County, Kansas, before the turn of the century, Jesse Nichols made his mark early as a salesman, turning profits on everything from fresh meat to Idaho mines. An established developer by 1908, he invested in statuary and other art objects for the neighborhoods he built. Nichols sent complimentary notes and occasional reprimands to homeowners, depending on the degree of care they lavished on their property.

Around 1920, Nichols began buying up swampland for a site for Country Club Plaza. The first major shopping center catering to customers who would come by automobile, the Plaza was planned with gas stations and garages. Parking lots, built to sit just below eye-level, were hidden by fences.

The first business at the Plaza, a beauty salon, opened in 1922. Customers were introduced to something new — the permanent wave. In the more than sixty years that have passed since then, Jesse Nichols' Plaza has continued making waves as a shopping center permanently ahead of its time.

●

THE OLD POST OFFICE

In 1971 a demolition contract had been signed for the Old Post Office, in Washington, D.C. The ten-story Romanesque Revival castle on Pennsylvania Avenue was destined for the rubble heap.

Today, thanks to local preservationists and a $30-million restoration, the old building is alive with activity, putting a new spin on the expression "mixed-use."

Government agencies (including the National Endowment for the Arts) occupy the building's 120,000 square feet of office space. Shops and restaurants spread across the building's lower levels, where postal clerks once sorted mail. Finally, there is a vertical national park — the building's clock tower — where tourists take the elevator to admire the bells up top and the view of Washington outside.

For the Old Post Office, 1971 was not the first time it evaded a date with dynamite. In the 1930s, when the building appeared to stand in the way of completing a complex of government office buildings in the downtown Federal Triangle, a local newspaper called the post office a "granite pile" and urged its destruction.

Washington, D.C. architect Arthur Cotton Moore was among the preservationists who lobbied to save the Old Post Office in the 1970s. In 1977 Moore's firm won the federal design competition to restore the building. He gutted much of the building's interior and replaced the metal roof with a skylight. Now sunlight pours into the atrium, illuminating federal corridors as well as the retail "Pavilion" that lies 215 feet below the glass roof. In the Pavilion, a raised stage sits at the foot of the clock tower. Free concerts and other entertainment are booked daily. "We made it into a playful building," Moore told *Historic Preservation* magazine. "It's not just another federal building."

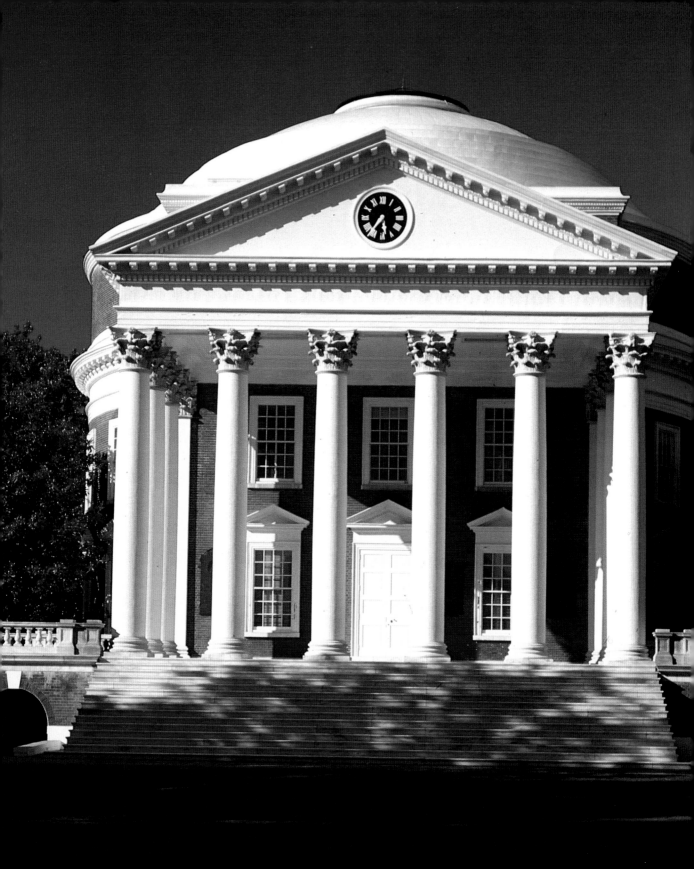

UNIVERSITY OF VIRGINIA

"Architecture is my delight," Thomas Jefferson once said, "and putting up and pulling down, one of my favorite amusements."

In Charlottesville, Virginia, America's most notable amateur architect created one of the world's great architectural conceptions. The beauty of Jefferson's design for the University of Virginia lies not in any single detail or building, but in the order and purpose that create harmony among separate architectural parts.

Jefferson's principal object was to establish an institution of higher learning befitting a young republic—"an academical village . . . afford[ing] that quiet retirement so friendly to study." But he also believed that buildings themselves can be tools for teaching and instruments of civilization. He intended that the university pavilions would serve as "models of taste" and "specimens for architectural lectures."

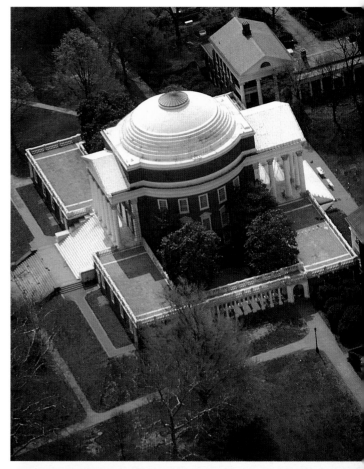

The Lawn, the name for the complex that Jefferson designed, has as its centerpiece a domed Rotunda. Inspired by the Roman Pantheon, and containing the university library, it is flanked by ten classical pavilions, five on each side. These were the university's ten schools, and each held classrooms as well as professors' living quarters. Behind the two-story pavilions came single-story dormitories for students. Between these building rows, Jefferson left space for the gardens that were delineated by a serpentine wall. A practical visionary, he designed the undulating wall partly to save on materials; a curving wall would be stronger than a straight one, and could be built one brick thick.

After retiring from the presidency, Jefferson devoted much of his time to creating America's first non-church university. He was seventy-four when he laid the cornerstone for the first campus structure, in 1817. When Jefferson died, on July 4, 1826 only the Rotunda remained to be completed. One hundred and fifty years later, the American Institute of Architects declared the university buildings and grounds designed by Jefferson the nation's foremost architectural achievement.

EAMES HOUSE

T wo boxes framed in steel — with walls of glass and stuccoed industrial sheeting — the Charles Eames house and studio in Pacific Palisades, California, "is serene and utterly unpretentious . . . the parent of virtually all of the 'high-tech' buildings of today," wrote Paul Goldberger, architecture critic for the New York *Times*.

"Unlike these descendants, however, which often seem to be following a fashion that celebrates industrial imagery as an end in itself, the Eames house makes of its industrial materials a gentle esthetic."

Best known for the form-fitting chairs that bear his name, Charles Eames was also a film maker and a designer of movie sets, toys, exhibits, and — during World War II — stretchers and splints. Born in St. Louis, he flunked out of Washington University, where he had been studying architecture. Later, he was invited to the Cranbrook Academy of Art by its director, Finnish architect Eliel Saarinen, where Eames became head of the experimental design department.

In the late 1940s, Eames designed — for his own home — one of the most celebrated houses of the twentieth century. Set between a hillside and a row of eucalyptus trees, the Eames house had been commissioned as a case study by *Arts & Architecture* magazine, and it was to be built entirely of industrial products that could be ordered from catalogs.

The house's skeleton consists of 4-inch by 4-inch steel columns, with diagonal braces absorbing wind loads, and a light skin of steel sheeting and glass. The living room is the full height of the two-story house. Two upper bedrooms, reached by a spiral stairway, have sliding panels that open onto the living room below. At the opposite end of the rectangular house, there is a two-story studio.

Charles Eames and his wife and professional collaborator, Ray Kaiser Eames, decorated the house with sculpture, Indian artifacts, toys, seashells, and other items. "The house is really less an industrial object than an industrial container for other kinds of objects," wrote Paul Goldberger. "The overall effect to a first-time visitor was rather like being inside a Joseph Cornell box."

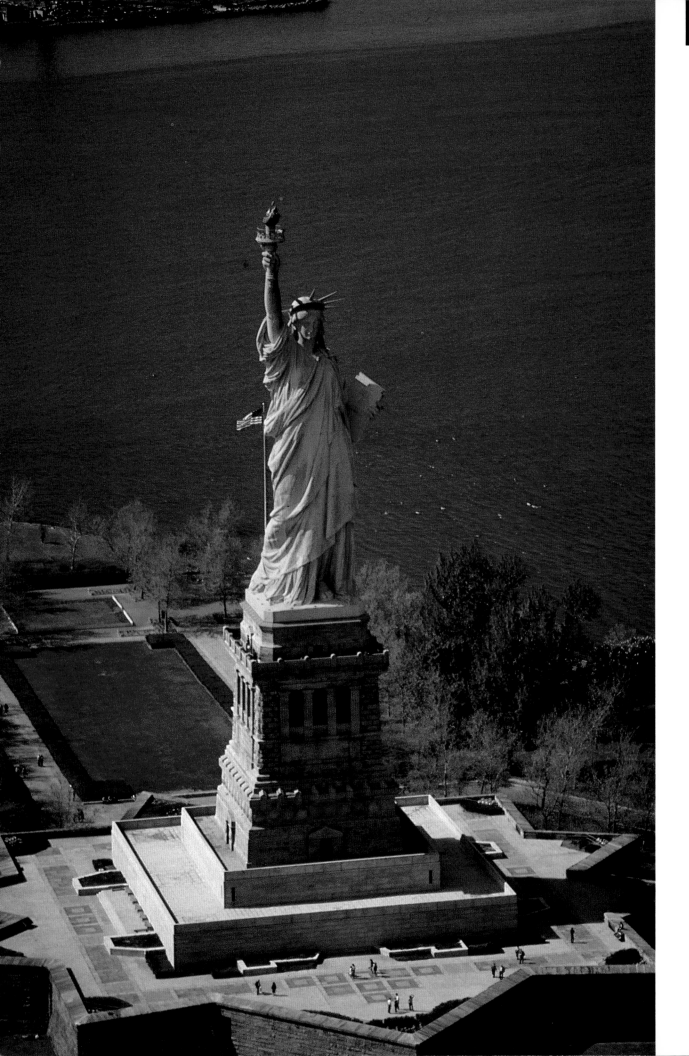

STATUE OF LIBERTY

Even though it was New York's tallest structure when dedicated in 1886, and a gift that commemorated our independence, the Statue of Liberty—now a national icon—received a frosty reception in America.

"Liberty Enlightening the World," as the statue was originally named, was only grudgingly accepted by Congress. The gift of the people of France was condemned in some circles as a "pagan goddess." One New York newspaper, in an editorial, fretted whether—"in view of the climate"—the figure would arrive properly draped. The statue that has become a symbol of freedom to millions of immigrants and would-be immigrants, had no place to stand until Joseph Pulitzer, the Hungarian-born press baron, used his New York *World* to whip up enthusiasm, and dollars, to complete a pedestal on Bedloe's Island.

That pedestal is nearly as remarkable as the sculpture it supports. Designed by American architect Richard Morris Hunt, the classical pedestal is 154 feet high. Its concrete walls are clad in pink granite. With the 53-foot-deep foundation on which its rests, it was the single greatest mass of concrete yet poured. Yet for all its bulk, it remains a proper pedestal, three feet taller than the statue above, yet never upstaging it.

Created by sculptor Auguste Bartholdi, her gown of copper hammered to a thickness of only 3/32 of an inch, the Statue of Liberty gets further support from the iron skeleton devised by Gustave Eiffel, the engineer who later designed the Paris tower that carries his name. With a central iron pylon bearing the weight of the statue, and a secondary internal framework lightly but firmly holding Bartholdi's sculpture in place, Liberty contracts or expands with changing temperatures, and gives slightly before the wind. America's best-known piece of sculpture is thus also one of the earliest examples of curtain-wall construction.

Arriving by ship, packed in 214 crates, it was an expensive marvel. The statue alone is estimated to have cost more than $400,000 to create. Building the pedestal and erecting the gift from France cost another $350,000. On the other hand, restoration of the Statue of Liberty, for its 1986 centenary, is expected to cost approximately $30 million.

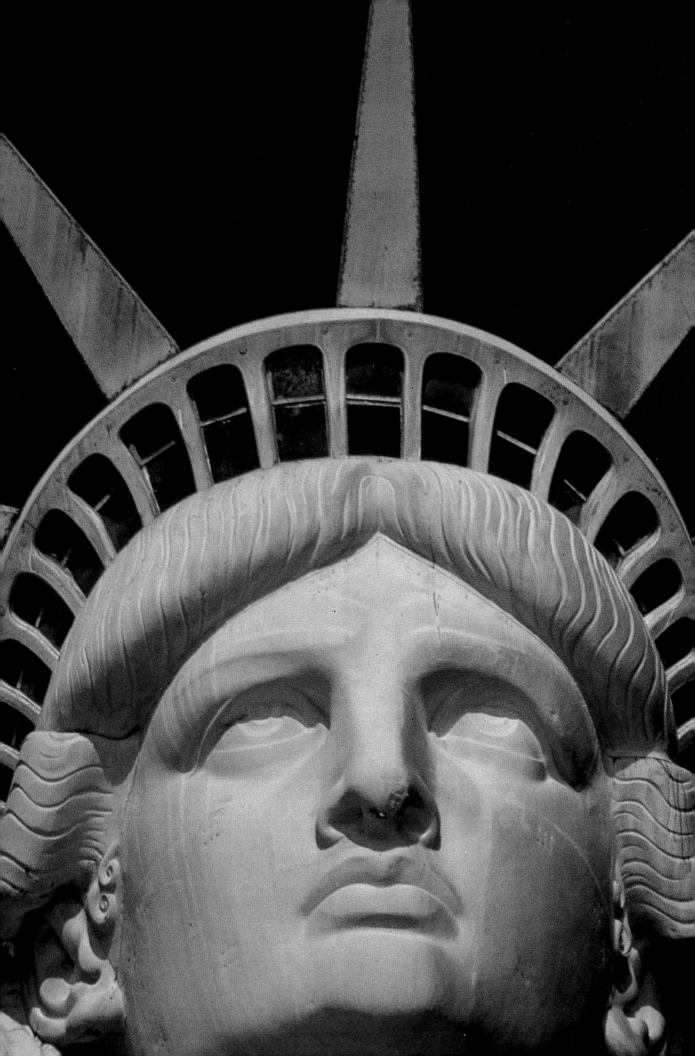

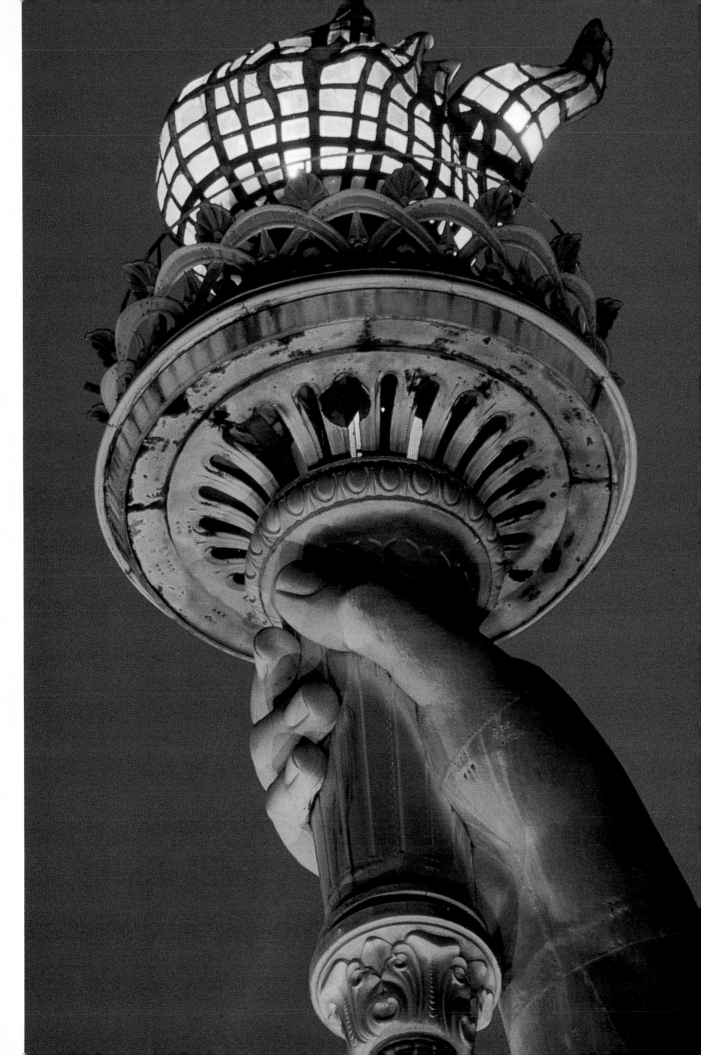

MESA VERDE

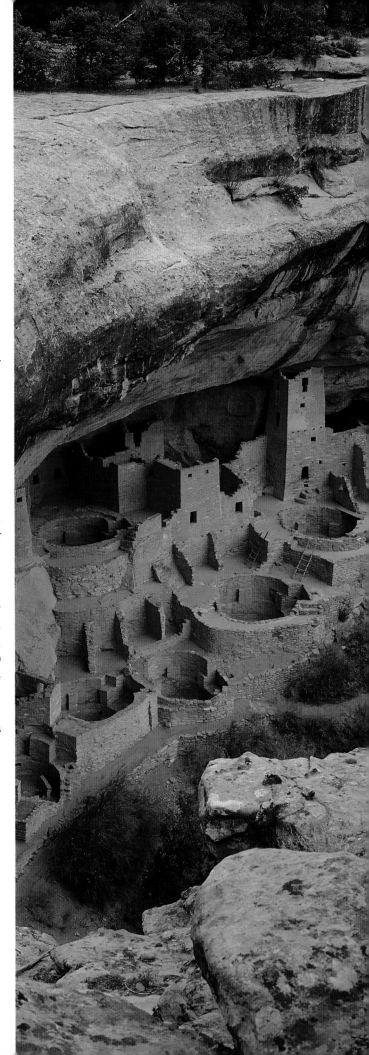

The cliff dwellings of Mesa Verde National Park are America's first apartment houses. Constructed more than two centuries before Columbus sailed for the New World, the ruins remain an architectural triumph and an archeological puzzle.

Nestled in the canyon country of southwestern Colorado, the multi-story houses were built by Anasazi Indians, "the ancient ones" in the Navajo language. Scarcely a hundred years after they were built, the cliff dwellings, and the mesa itself, had been abandoned. No sure explanation exists for the Anasazi's departure from Mesa Verde. Enemy harassment, drought, and overpopulation have all been suggested by archeologists as possible reasons.

We do know that the architectural flowering that led to the cliff houses is unique in prehistoric North America. The Anasazi's earliest pole and mud houses, constructed atop the mesa, were followed — over a span of centuries — by the immense structures of coursed masonry built along the walls of rugged canyons.

The dwellings remained undisturbed until December 1888, when two cowboys chasing strays came upon "Cliff Palace" — the largest cliff dwelling in the United States. Constructed in a cave that is 325 feet long, 90 feet deep, and 60 feet high, Cliff Palace contains more than 200 rooms.

Ransacked for years by pothunters, Mesa Verde's ancient apartments became a national park in 1906.

Urban design, architecture, and public art are the subjects of a vast literature. Anyone seeking a fresh viewpoint on his city, or on ways that places can be art, may profit from reading such fundamental texts as Edmund Bacon's *Design of Cities*, Jane Jacobs' *The Death and Life of Great American Cities*, Kevin Lynch's *The Image of the City* and *A Theory of Good City Form*, Lewis Mumford's *The Culture of Cities*, or Paul Spreiregen's *Urban Design: The Architecture of Towns and Cities*. Works by earlier writers, such as the 19th-century landscape architect Frederick Law Olmsted (see *Civilizing American Cities: A Selection of Frederick Law Olmsted's Writings on American Landscapes*, edited by S.B. Sutton), or Leon Battista Alberti (his *Ten Books on Architecture*, published in 1485, suggests that the city "should by no means be either so big as to look empty, nor so little as to be crowded," and offers practical advice on the making of squares and on other subjects), can have as much to tell us as the latest issue of a contemporary professional journal. For a highly personal, and witty view of the ills of 20th-century architecture, turn to Tom Wolfe's *From Bauhaus to Our House*. A selective list of other useful books and articles follows:

Beardsley, John. *Art in Public Places: A Survey of Community Sponsored Projects Supported by the National Endowment for the Arts*. Andy Leon Harney, ed. Washington, DC: Partners for Livable Places, 1981.

Fleming, Ronald Lee and Renata von Tscharner. *Place Makers: Public Art That Tells You Where You Are*. New York: Hastings House, 1981.

Green, Kevin W., ed. *The City as a Stage: Strategies for the Arts in Urban Economics*. Washington, DC: Partners for Livable Places, 1983.

Handbook of Architectural Design Competitions. Washington, DC: American Institute of Architects, 1981.

Lynch, Kevin. "The Immature Arts of City Design." *Places* 1 (Spring 1984): 10-21.

National Endowment for the Arts. *Design Competition Manual*. Cambridge: Vision, The Center for Environmental Design and Education, 1980.

Page, Clint and Penelope Cuff. *The Public Sector Designs*. Washington, DC: Partners for Livable Places, 1984.

Battery Park City

Pelli, Cesar and Nancy Rosen. "The Chemistry of Collaboration: An Architect's View." In *Insights/On Sites*, edited by Stacy Paleologos Harris. Washington, DC: Partners for Livable Places, 1984.

Tomkins, Calvin. "The Art World: Perception at All Levels." *The New Yorker*, 3 December 1984.

Boston

"The Livable City? — Surging Growth Confronts Boston's Legacy." *The Boston Globe*, 11 November 1984.

Columbus

A Look at Architecture: Columbus, Indiana. Columbus Area Chamber of Commerce, Inc., 1984.

Miami

Brown, Patricia Leigh. "Designs on Miami: The Young Partners of Arquitectonica Have a Blueprint for the City of the Future." *Esquire*, December 1984.

Minneapolis

"Center City Profile." *Design Quarterly* 125, Walker Art Center, 1984.

New York

Wiseman, Carter. "High Rise, Hard Sell: Now, 'Designer' Skyscrapers." *New York*, 11 March 1985.

Philadelphia

Slovic, David and Ligia Rave. "Building of the Month Awards: Philadelphia." *Places* 1 (Spring 1984): 44-59.

San Francisco

Downtown: Proposal as Adopted by the City Planning Commission as a Part of the Master Plan, November 29, 1984. San Francisco Department of City Planning.

Santa Fe

Design & Preservation in Santa Fe: A Pluralistic Approach. Planning Department, City of Santa Fe, January 1977.

Seattle

Andrews, Richard. "Artists and the Visual Definition of Cities: The Experience of Seattle." In *Insights/On Sites*, edited by Stacy Paleologos Harris. Washington, DC: Partners for Livable Places, 1984.

Artwork Network — A Planning Study for Seattle: Art in the Civic Context. Seattle Arts Commission, 1984.

Tomkins, Calvin. "The Art World: Perception at All Levels." *The New Yorker*, 3 December 1984.

PICTURE CREDITS